IMAGES
of America

THE TIBURON
PENINSULA

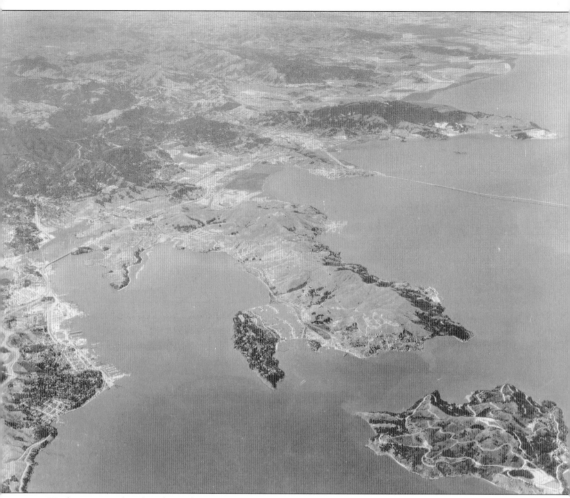

Highway 101 divides the Tiburon Peninsula from the rest of Marin County. Angel Island, the largest island in San Francisco Bay, is a part of the Town of Tiburon. Sausalito is on the left in this aerial photograph.

ON THE COVER: This 1956 aerial view shows the Tiburon and Belvedere waterfront.

IMAGES
of America

THE TIBURON PENINSULA

Branwell Fanning

ARCADIA
PUBLISHING

Published by Arcadia Publishing
Charleston SC, Chicago IL, Portsmouth NH, San Francisco CA

Printed in the United States of America

Library of Congress Catalog Card Number: 2006924393

For all general information contact Arcadia Publishing at:
Telephone 843-853-2070
Fax 843-853-0044
E-mail sales@arcadiapublishing.com
For customer service and orders:
Toll-Free 1-888-313-2665

Visit us on the Internet at www.arcadiapublishing.com

"If ye seek his monument then look about thee" is inscribed (in Latin) on Sir Christopher Wren's tomb in London. In the same spirit, this book is dedicated to all those who have worked countless hours preserving the land and sea to create the Tiburon Peninsula we enjoy today.

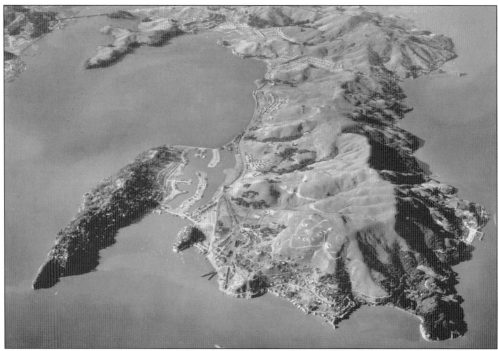

Tiburon, Belvedere, and Strawberry are featured in this 1954 aerial photograph.

CONTENTS

ACKNOWLEDGMENTS

Prior to meeting with Hannah Clayborn, my editor at Arcadia Publishing, I delivered a series of "Then and Now" slide presentations on the Tiburon Peninsula. Hannah cautioned me that in the Images of America series, the "then" was much more important than the "now." Tiburon was the first place in Marin County to be settled, but it is also the newest city. Its "then" often overlaps with its "now." The 127 years between the time John Reed built his adobe hut in 1837 and the incorporation of the city of Tiburon in 1964 was filled with many exciting happenings, but serious development waited until after the end of World War II.

Fortunately that is when the Belvedere Tiburon Landmarks Society started to save memorabilia, photographs, and even buildings so that we have some record of what happened in the early days. The Landmarks Society images I have used are identified by "LMS Archives." I must thank Piper Berger, a trained archivist, for her assistance in retrieving material from their extensive files and the people who have donated to their collection. Phil Cassou, president of the society, helped date many old photographs through his knowledge of vintage automobiles.

Chris Morrison, who grew up here and started saving postcards and photographs of his hometown at an early age, is the proprietor of The Attic on Ark Row, a collector's haven. Chris gave me complete access to all the collections and files in his shop. These are identified as "Morrison collection."

For almost 40 years, Ed Brady of Aero Photographers took to the air on any clear day and captured remarkable aerial views of Marin County. His widow, Gretta, allowed me to use his collection for this book, so all of the aerials are from Ed Brady's collection. Dave Gotz, chairman of the Heritage and Arts Commission, allowed me to use his scans of the Brady aerials and other photographs from his collection. Fred Codoni of the Northwestern Pacific Railroad Historical Society (NWPHS) was also very helpful in providing historical photographs of the railroad days in Tiburon. Otherwise the images are identified by the source or are from my personal files.

More than 50 years ago, I had the good sense to marry a high-school English teacher. Carolyn Fanning has edited, re-edited, and corrected the copy in the Images of America: *Tiburon Peninsula*, as she has throughout my career writing travel books and articles.

INTRODUCTION

Three communities that appear quite similar today occupy the four-mile-long, one-mile-wide Tiburon Peninsula in southern Marin County, California. The Town of Tiburon contains most of the land plus Angel Island and about 10 square miles of San Francisco Bay. The city of Belvedere is on two islands connected to the Tiburon Peninsula by causeways. The unincorporated Strawberry Peninsula and the homes on rustic Paradise Drive complete the Tiburon Peninsula community. They were all part of the same Mexican land grant, given to the Reed family in 1834, and are interrelated to such an extent that this book treats them as one. However they followed different paths from the land-grant era to the present.

Historically Tiburon was a vigorous industrial center. Railroad cars, locomotives, and some of the largest ferryboats ever seen on San Francisco Bay were built there. Codfish packing plants, dairies, army and navy installations, and cattle ranching employed hundreds of workers. Although the first settlers came in the 1830s and the post office opened in 1884, Tiburon is the newest incorporated town in Marin County. Begun as the City of Tiburon in 1964, the voters changed its name to the Town of Tiburon in 1979.

Belvedere is one of the oldest cities in Marin County, having incorporated in 1896 as a subdivision for wealthy San Franciscans who built weekend country homes. After the 1906 earthquake and fire destroyed their San Francisco properties, many moved to Belvedere temporarily and ended up staying permanently.

Belvedere and Tiburon retain separate governments, although they share many services. One school district serves both communities, and they are served by one post office and zip code. A community library serves both. Churches of each denomination, some in Belvedere and some in Tiburon, serve the entire peninsula. The Tiburon Fire District answers calls from both communities. A joint recreation district makes it possible for the children of both communities to play together.

Strawberry remained a dairy ranch until after World War II and was briefly considered as the site of the United Nations headquarters. Strawberry, along with the other unincorporated areas of the peninsula, is governed by the County of Marin, although the Strawberry Recreation District functions as a quasi-council for that area.

Both Belvedere and Tiburon have a city/town manager form of government. Councilmen are elected to four-year terms, and they elect a mayor who serves for one year. The city/town manager runs the day-to-day operations. Elected officials serve without pay. Even without shopping malls or auto rows, both towns have a history of balanced budgets and little or no debt.

Having water on three sides and sheltered from Pacific winds by majestic Mount Tamalpais, the Tiburon Peninsula enjoys a Mediterranean-type climate that is mild in both summer and winter. Yachting and tennis are favorite forms of recreation, and the communities support three yacht clubs, four tennis clubs, and a number of public tennis courts.

Tiburon's quaint Main Street and Ark Row fill with visitors throughout the year. Recently bicycles have become a favorite mode of recreation for residents and visitors, who bring their bicycles

on the ferryboat. What was once a railroad right-of-way has been turned into a three-mile-long bicycle and pedestrian path bordering a 900-acre wildlife preserve and Audubon sanctuary.

Tiburon is somewhat unique in that it is divided by a large body of water without a bridge connecting the two parts. The Angel Island part has had an interesting past. The first explorer made it his headquarters and gave it its name. Angel Island has hosted coast artillery batteries, an immigration station, military and immigration hospitals, a POW camp, and a Nike missile base. It is now part of the California state-park system.

Many of the charming homes in Belvedere were built a century ago, but Tiburon and Strawberry escaped development until after World War II because one family owned most of the rest of the peninsula and had no desire to sell. Over the years, there were many schemes to take advantage of the central location and availability of the Tiburon Peninsula. Bridges to all parts of the Bay Area, along with missile-testing ranges, ammunition depots, and other inappropriate uses, have been actively promoted. Fortunately citizen groups rallied together and have kept most of the hills and bays undeveloped.

The Tiburon Peninsula schools are among the finest in the state and add to the peninsula's desirability as a residential community. In 1985, the completion of the Point Tiburon development in the former railroad yards signaled a change in the population mix and needs of the downtown area. In 1997, a new town hall was opened with a new library next door. The town then acquired more waterfront land and created Ferry Landing and Plaza, a waterfront park. Extending from the ferry landing to the Elephant Rock Fishing Pier, it includes the Donahue Building, the last survivor of the railroad's presence.

The residential areas of town are almost built out. Those areas that wished to be within the town limits have been annexed, and the town has grown westward from its original base. A few "in-fill" lots are scattered about, but no new subdivisions of any size are possible unless precious open space is sacrificed, which is an unlikely happening.

One

EXPLORERS, NATIVES, AND SETTLERS

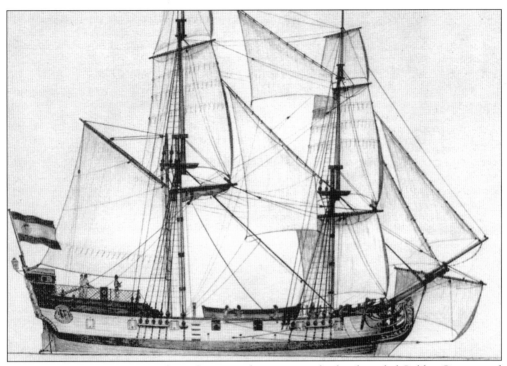

For 200 years, every pirate, merchant ship, or explorer passing the fog-shrouded Golden Gate missed entering San Francisco Bay. In 1775, after the bay was discovered by Spanish soldiers traveling overland from Monterey, Lt. Juan Manuel de Ayala was ordered to take his ship, the *San Carlos*, only 80 feet long, and explore and map this huge body of water. In August that year, the crew of the *San Carlos* crept into San Francisco Bay. Sailing through the narrow opening from the Pacific Ocean, Lieutenant Ayala saw a giant land formation in the shape of a shark surrounded by water that was actually home to many sharks. He thus named the land Punta del Tiburon, or Shark Point, and proclaimed it Spanish territory. Jose Canizares, the pilot of the *San Carlos*, was delegated to explore the bay while Lieutenant Ayala recovered from a foot injury. Canizares made detailed maps and soundings throughout the bay and named many of the most prominent points. They named the island where they were moored Isla Santa Maria de Los Angeles, now called Angel Island, and they called their sheltered anchorage Ayala Cove. Lieutenant Ayala and his crew were greeted by friendly members of the Coast Miwok tribe who had been living in the area for thousands of years. They had several settlements on the peninsula but no permanent housing. Huge shell mounds marked the places where they settled. Rock carvings in the hills can still be seen. (Courtesy San Francisco Maritime Museum.)

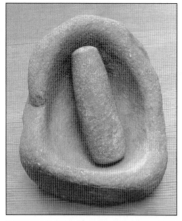

For thousands of years, the tribes known as the Coast Miwoks lived in Southern Marin. They left evidence of their existence in the numerous shell mounds where they harvested the bounty of the seas around Tiburon. The hills of Tiburon were covered with oak trees at that time, and acorns made up a substantial part of their diet. The acorns were ground into a flour in a mortar similar to this one found by Tiburon Historian Louise Teather in 1950. The flour was leached in water and then could either be baked or eaten as mush. Arrowheads left near the settlements indicate hunting for deer and other small game also contributed to their diet. (LMS Archives.)

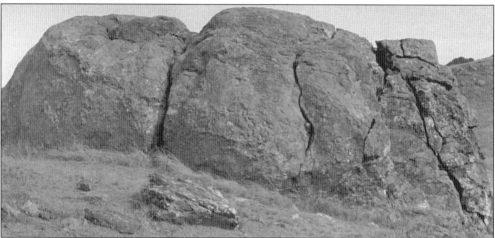

This giant rock is filled with petroglyphs (close-up below) carved thousands of years ago. Scientists believe they were carved by women, but the reason is unknown. They were symbolic rather than pictorial. The natives were friendly to the crew of the *San Carlos*, but when Spanish and Mexican settlers arrived, the natives were enslaved and transferred to Mission San Rafael. European diseases for which they had no immunity soon claimed a majority of the tribes. (LMS Archives.)

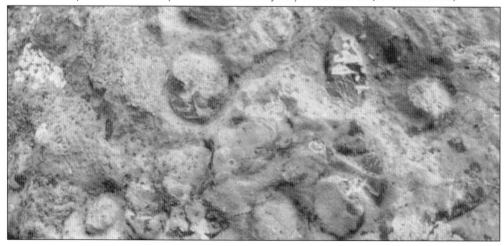

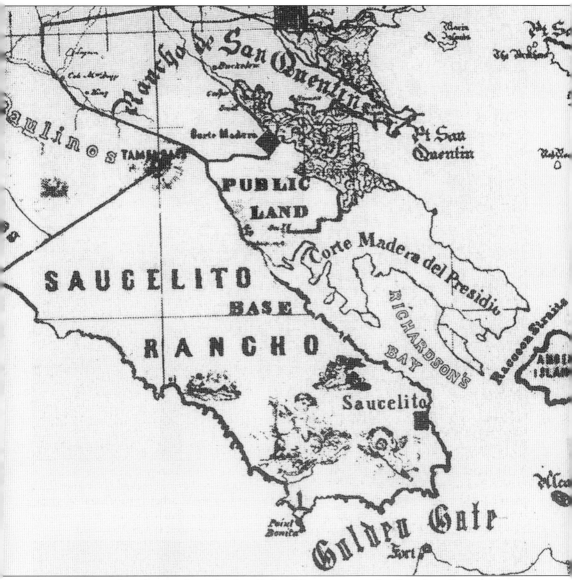

Forty-six years after the visit from the *San Carlos*, Mexico won its freedom from Spain and took dominion over Spanish lands in California. Mexico seized the mission lands and granted property to settlers who were Catholic, could speak Spanish, agreed to live on the land, and demonstrated loyalty to Mexico. In 1834, John Thomas Reed, an Irishman who had lived in Mexico, was granted 8,578.32 acres, approximately two square leagues. The grant included all of the present-day Town of Tiburon (except Angel Island), Belvedere, Mill Valley north of Miller Avenue, all of Corte Madera, and Larkspur up to Corte Madera Creek. In 1848, Mexico ceded California to the United States and, in 1850, it was admitted to the Union. The portion of the original Mexican grant that was confirmed to the Reeds by the U.S. Land Commission in 1856 is designated on this map as *Corte Madera del Presidio* ("Where wood is cut for the Presidio"). The area marked "Public Land" was not confirmed to the Reeds until the 1880s.

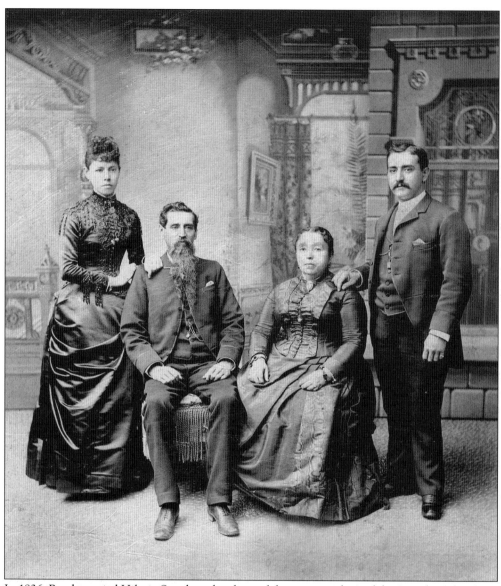

In 1836, Reed married Hilaria Sanchez, daughter of the commandant of the Presidio. They bore two sons, Ricardo, who died before reaching adulthood, and John Joseph, and two daughters, Hilarita and Maria Inez. John Joseph is pictured here with his wife, Carlota, his daughter Clotilde, and their son John Paul. Hilarita Reed married Dr. Benjamin Lyford. Maria Inez inherited 646 acres in present-day Mill Valley, married Thomas Deffebach, and had 11 children. Only four lived to adulthood. (LMS Archives.)

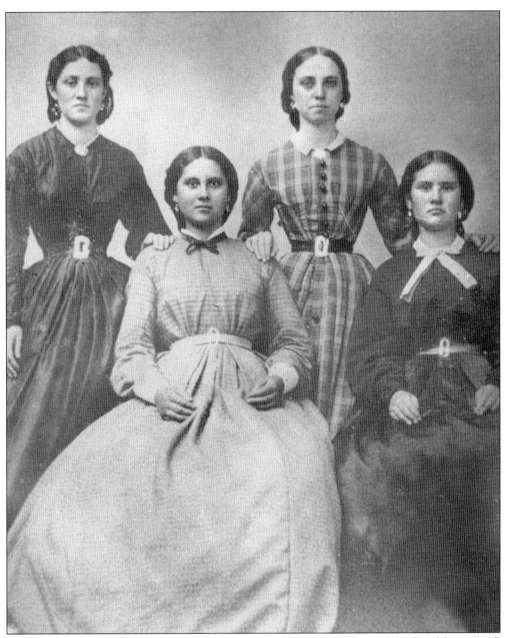

Holding perfectly still for the photographer in the 1860s are women of the Reed household. Standing at the top are the two daughters of John Thomas Reed, Maria Inez Reed Deffebach and Hilarita Reed Lyford. Seated at lower right is half sister Carmelita Garcia, whose mother was the widow of John Thomas Reed. Perhaps the more interesting member of this family group was Barbara Sibrian, seated at lower left, who was the unwed mother of John Joseph's daughter Clotilde Reed. Raised in the Reed household, Clotilde ended up inheriting the majority of the Reed Ranch after the death of her father and brother. Missing from the photograph is Elvira Alice Reed, a second illegitimate daughter of John Joseph, who was not known to the family until he left her 100 acres at El Campo on Paradise Drive in his will. Successful soap operas have had less complicated plots. (Lucretia Little collection.)

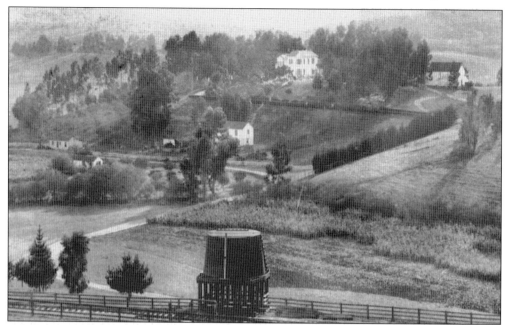

John Joseph Reed inherited the bulk of the original Reed ranch from his father John Thomas Reed and built an imposing Victorian residence high on a knoll in what is now Cypress Hollow. From there, he could survey most of his vast holdings. He moved his family there from the adobe in Mill Valley and lived here until his death in 1899. His son John Paul also lived here, unmarried, until his death in 1919.

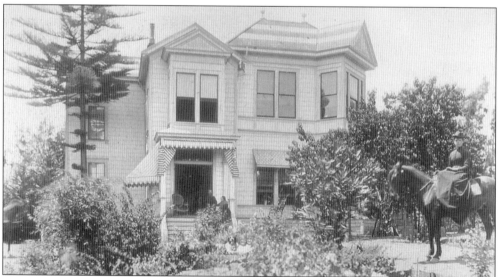

The Reed family held many fiestas at this grand Victorian manor. Pictured here on her horse is Reed's illegitimate daughter, Clotilde, who was raised in the family home. Unmarried, Clotilde inherited the bulk of the land following the death of her half brother in 1919 and lived in this house the remainder of her life. By the time of her death in 1940 at age 81, she owned 2,015 acres—433 acres on the Strawberry Peninsula, the 1,033 acres of the Big Reed Ranch, and the 544 acres of Little Reed Ranch. Because she died intestate, a final Decree of Distribution dividing the property among 14 heirs was not issued until 1956. (LMS Archives.)

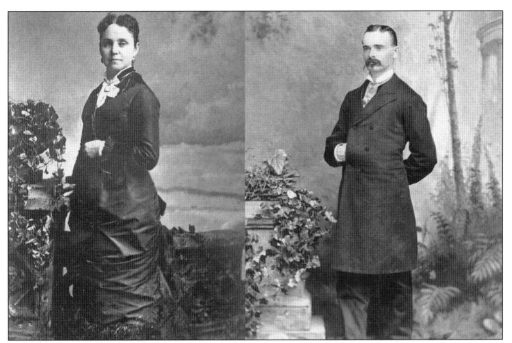

The first residents of Strawberry were Hilarita Reed Lyford and her husband, Dr. Benjamin Lyford. Hilarita inherited 446 acres of Strawberry along with 1,000 acres at the east end of the Tiburon Peninsula. She was only four years old at the time of her father's death, and it was not until she married Dr. Lyford (above, right) in 1872 that she was able to live on her property. (LMS Archives.)

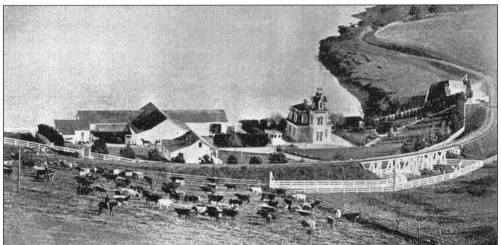

Dr. Benjamin Lyford served as an embalming surgeon during the Civil War, after which he arrived in San Francisco to set up a medical practice. There is no record of his ever having had any formal medical training, but that was not unusual in those days. One of his patients was Hilaria Reed Garcia, the mother of Hilarita Reed. Dr. Lyford married Hilarita Reed in 1872, and they settled on her property in Strawberry and joined in the family dairy business. The narrow-gauge North Pacific Coast Railroad made a stop at their Eagle Dairy to pick up butter, milk, and other dairy products. Dr. Lyford was a fanatic about sanitation and everything was painted white, including the rails. (LMS Archives.)

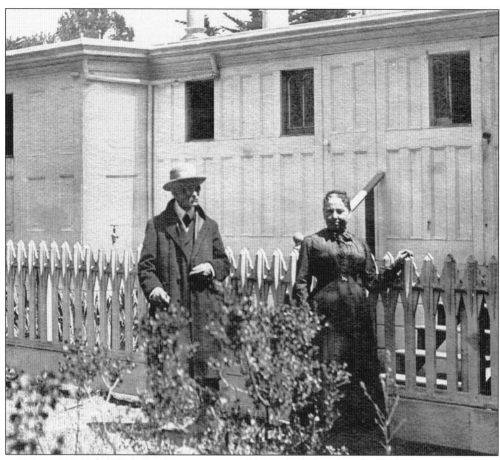

The Lyfords lived at the Eagle Dairy until his death in 1906 and hers in 1908. They no longer lived in the beautiful Victorian home they had built, but in this one-story structure, which appears to be a cabin salvaged from a ship. It is not the same ship's cabin visible in the photograph of the Eagle Dairy where he had performed his embalming experiments. (Dave Gotz.)

Rose Rodrigues Da Fonta was born in the Azores, and the family came to the Reed Ranch when she was three. She worked as a servant for Clotilde Reed and became the "dear friend" of John Paul Reed. Later Clotilde would not let Rose enter the Reed home, and John Paul sided with his sister. But John Paul never forgot Rose. Before he died, he deeded to Rose the 10 acres of land on which she lived, some of the most valuable land of the Reed holdings. (Audubon Society.)

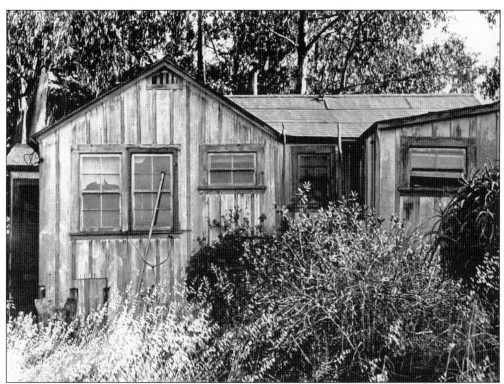

Instead of living out her life in the luxury she could have enjoyed if she sold her land, Rosie stayed in her cottage until the end of her days. She lived in the front and the goats in the rear. After her death in 1964, the National Audubon Society restored the cottage into a classroom for environmental studies.

Known as "Rosie the goat lady," Rose sometimes took her charges for a stroll on the Boardwalk in downtown Tiburon. She could often be seen walking along busy Tiburon Boulevard. She spurned all offers from developers for her waterfront site and, in 1957, gave it to the Marin Conservation League, who then deeded it to the National Audubon Society. Today it is the headquarters of the Richardson Bay Audubon Center and Sanctuary. (LMS Archives.)

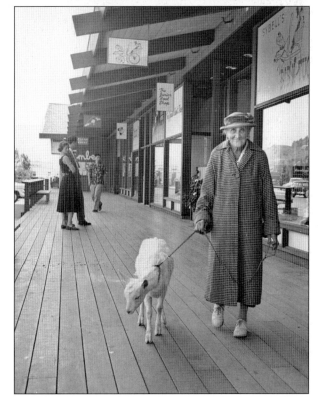

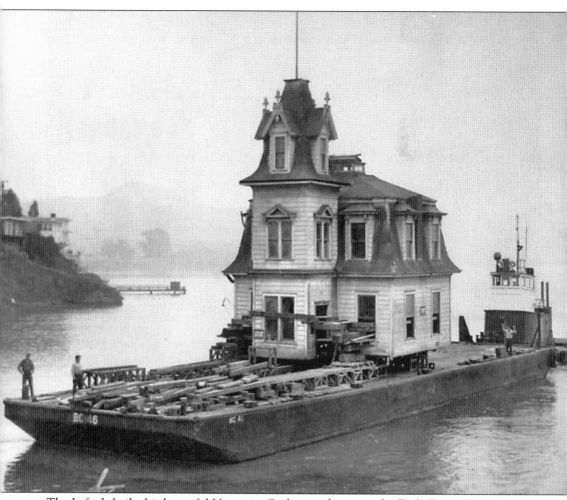

The Lyfords built this beautiful Victorian Gothic residence on the Eagle Dairy. In 1957, it was threatened with destruction, and as one of the oldest surviving houses in Marin County, concerned citizens raised the funds to move it across Richardson Bay to Rose's land. Rose chose not live in the Lyford's house, but romantics enjoyed the fact that one of the Reed homes she was not permitted to enter was sitting on her property. (Dave Gotz.)

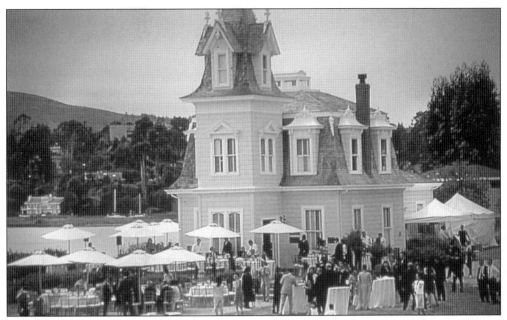

Having given everything she had to preserve her beloved land, Rose inspired the community, led by Caroline Livermore, to purchase 900 adjoining acres of tidelands for a wildlife preserve. Closed to boating during migrating season, the Richardson Bay Audubon Center and Sanctuary houses a quarter of a million birds that pause to rest and feed. The completely restored Lyford House is popular with local residents for weddings and other events.

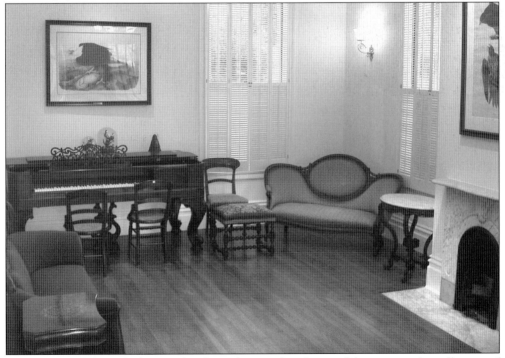

The interior of the Lyford House has been decorated with period furniture and a collection of original lithographs of James Audubon's paintings.

Rose's cottage has been restored and is now a classroom for environmental studies for children of all ages. They start with a shoreline study, "Tiptoe by the Tide Pool," for kindergarten ages and progress through all levels of bird identification and habitat restoration. Rosie would be pleased. Elizabeth Terwilliger, the famous "Mrs. T," taught many of these programs 50 years ago.

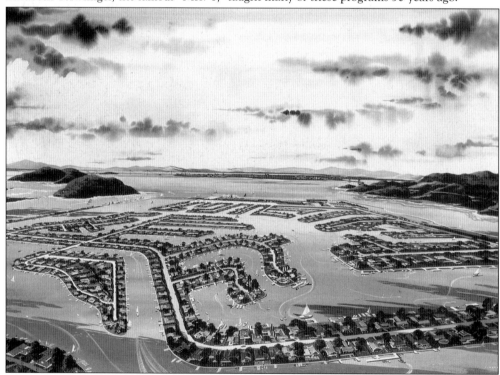

This is an artist's rendition of the Reeds Port plan, which Rose's dedication of her property sidetracked. A huge landfill in Richardson Bay for 2,000 homes and several yacht clubs would have changed southern Marin completely. This is now the Richardson Bay Audubon Sanctuary, a 900-acre preserve vital to the Pacific flyway. (Dave Gotz.)

The Railroad Era

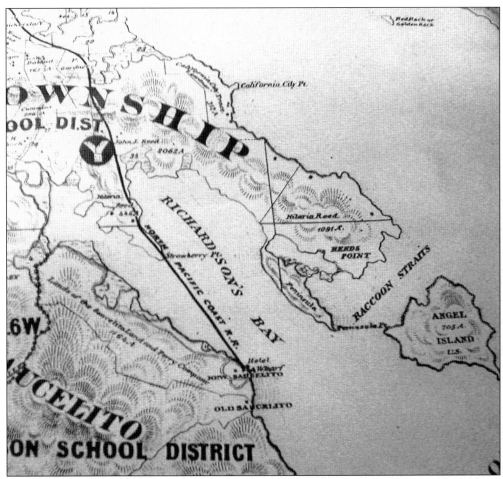

Peter Donahue was president of the San Francisco and North Pacific Railroad Company and was in a race for the northern California market. Sausalito was the prize as the closest rail/ferry port to San Francisco. In 1875, the narrow-gauge North Pacific Coast Railroad got there first by climbing over the hill between Corte Madera and Tiburon; following the shoreline of Strawberry, with a stop at the Eagle Dairy; and then crossing Richardson Bay to Sausalito on a 4,000-foot-long trestle. By the 1870s, Donahue had completed a railroad from the redwood lumber country to Donahue Landing on Petaluma Creek where passengers and cargo transferred to his steamers for the trip to San Francisco. By 1879, this line had been extended to San Rafael. His rivals, though, found a faster route to Sausalito by digging a tunnel from Larkspur to Mill Valley, bypassing Strawberry, so Donahue changed directions and headed for Point Tiburon. This meant digging three tunnels and building several long trestles across marshy fields, but by 1884, he was in Tiburon. (LMS Archives.)

Peter Donahue was one of three adventurous brothers from Dublin who opened a blacksmith shop in San Francisco in 1849. They expanded the business by making machines and boilers and finally moving into repairing locomotives and ships. After adding a foundry, they called their enterprise the Union Iron Works, which has long been one of San Francisco's major industrial complexes. After building and repairing railroad rolling stock, it was an easy step going into the project of building a railroad. By 1860, Donahue had completed a railroad from San Francisco to San Jose that is still in use today. To connect San Francisco to the north he built a fleet of ferries. On the other side of the Golden Gate he put together several small railroads and founded the San Francisco and North Pacific Railroad, which eventually brought him to Tiburon. He died in 1885, but the year before he set Tiburon on a path as an industrial center that lasted into the next century. Peter Donahue was one of San Francisco's early visionaries. Besides founding the Union Iron Works and several railroads, he also built a gas plant to turn coal imported from England into illuminating gas for street lamps. This company eventually became the Pacific Gas and Electric Company (PG & E). Tiburon has named the Railroad Depot Museum in his honor.

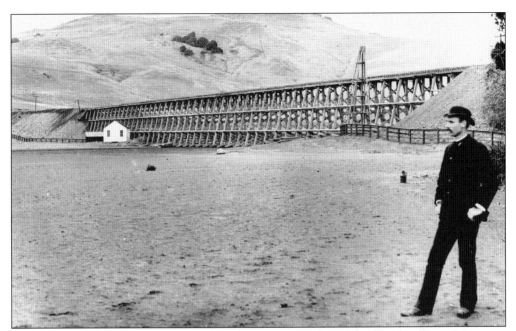

To reach the end of the Tiburon Peninsula, the SF&NPRR had to complete three tunnels between San Rafael and Tiburon. The last of these tunnels ended in a marshy area, which required this huge trestle that would give the area its name, Trestle Glen. Eventually a gap in the trestle would be required for Tiburon Boulevard to pass. The small, white building is the first school in Tiburon, serving children of the workers on the Reed ranches and the railroad. (LMS Archives.)

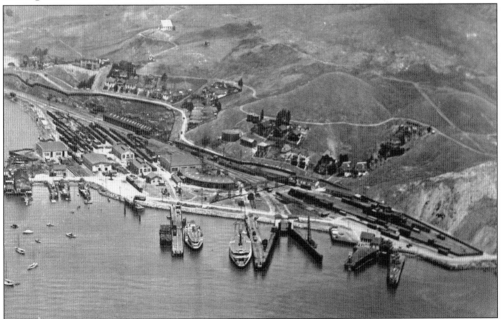

Donahue brought in gangs of Irish workers to lay track and build the railroad yards in Tiburon. They first blasted tons of rock out of the hillside and filled in the marshy areas at the end of the peninsula. They then had to pound piles into the bay in order to build piers for ferry boats and barges.

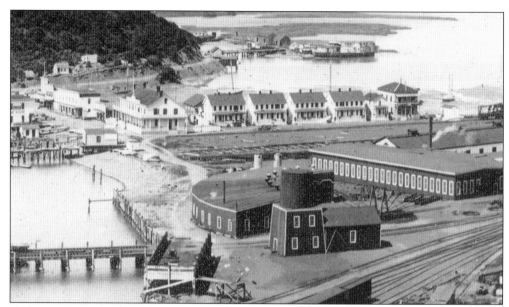

By 1886, almost the entire town of Donahue Landing had been moved from Petaluma Creek to Tiburon. A number of buildings were placed in the same order in Tiburon as they were in Donahue Landing, making it difficult to differentiate between the two locations. The 40-room Sonoma Hotel and the other white buildings in this 1890 panorama were barged down, but none of these survived the many fires that destroyed most of downtown Tiburon. (LMS Archives.)

After the railroad moved its southern terminal to Tiburon, the town of Donahue on the Petaluma Creek was abandoned. These cottages, moved at that time, are still in use as private homes in Tiburon.

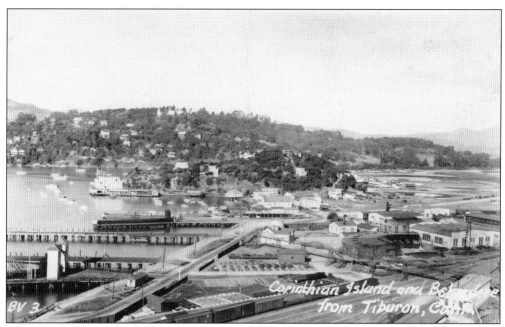

The original Corinthian Yacht Club, located on the end of Corinthian Island and financed in part by Peter Donahue's son James, was destroyed by fire in 1910. The familiar white colonnaded building was constructed in 1912. The foreground shows a busy rail yard. (LMS Archives.)

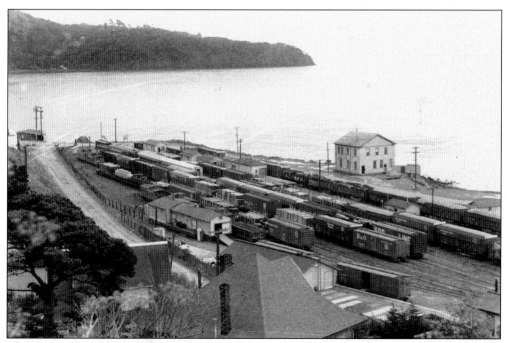

This is the Tiburon railroad yard in 1950. The merger of five railroads in 1907 had created the Northwestern Pacific Railroad (NWP). After the merger, San Francisco–bound passengers traveled via Sausalito. Freight traffic and maintenance were concentrated in Tiburon. A shuttle ferried passengers between Tiburon and Sausalito, with a stop in Belvedere. (LMS Archives.)

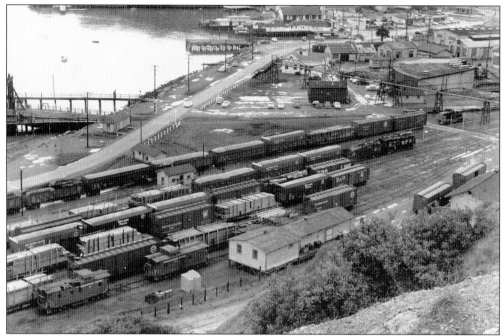

At its peak, the Northwestern Pacific Railroad carried over 300,000 tons of freight yearly and more than 1,200,000 passengers. Lumber, meat, and dairy products were the main cargos southbound and beer and whiskey were second only to agricultural implements northbound. (LMS Archives.)

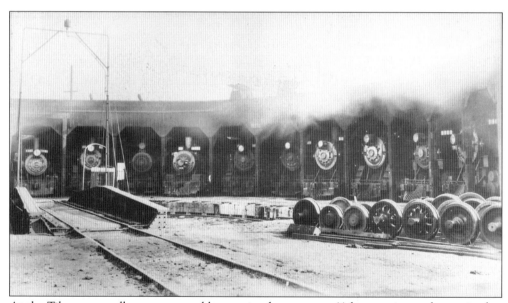

At the Tiburon roundhouse, a turntable permitted as many as 11 locomotives to be serviced at one time. Massive hoists could lift the heaviest equipment to have wheels replaced (like those in the foreground) and other mechanical work done. The adjoining industrial shops could assemble both locomotives and railroad cars. (LMS Archives.)

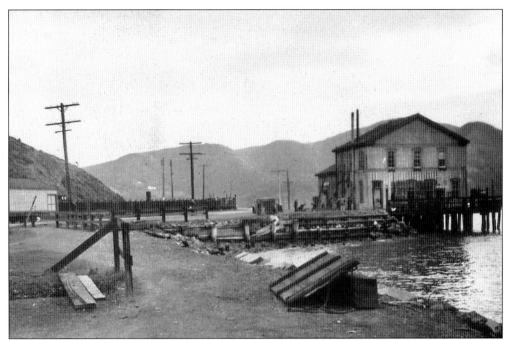

Originally the Donahue Depot was on piles in the bay. It may have been moved back to dry land or the waterfront extended out around it. It is recorded as the only dual terminal west of New York—a rail terminal on one side and a ferry landing on the other. (NWP.)

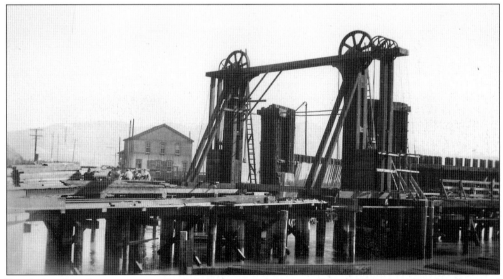

Loaded railroad cars were pushed directly onto barges or ferries, thus avoiding loading and reloading them on each end. This was made possible by the gallows frame that raised and lowered the rail bed to match the tides. The gallows frame remained a fixture on Tiburon's waterfront until this pier was demolished in 1974. The huge wheels on top were salvaged to be exhibited at the railroad museum. (NWP.)

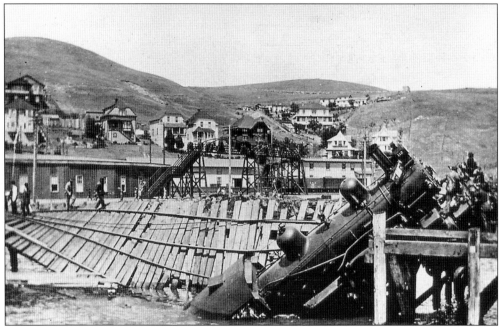

The system did not always work as designed. Old No. 112, built in the Tiburon yards, went for a little swim one sunny day in June 1913. Hauled out, dried out, and put back on the rails, No. 112 ran until the last days of steam trains on the Tiburon route. It is now on exhibit in the Railroad Museum in Sacramento, still proudly sporting the Northwestern Pacific logo. (LMS Archives.)

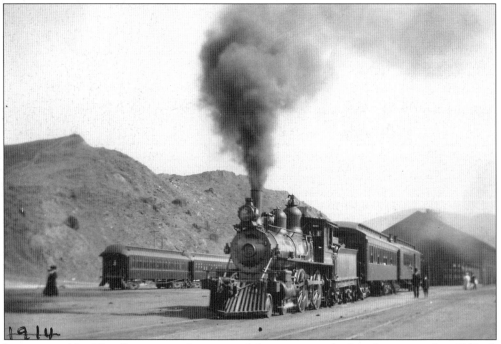

Locomotive No. 18 pulls a string of cars out of the passenger shed at the terminal in 1909. A detailed model of the Tiburon terminal as it was in 1909 has been built in the Railroad Museum (Donahue Building), complete with ferry boats and working trains. (LMS Archives.)

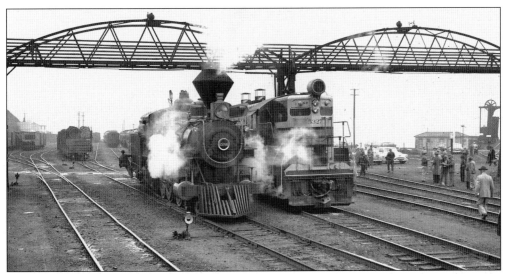

Logs from the vast forests provided fuel for early Northwestern Pacific locomotives. To avoid setting those forests ablaze, huge spark arresters were necessary. A change to oil as the primary fuel eliminated that need. Eventually diesel-electric locomotives replaced steam. The pedestrian viaduct above the locomotives connected homes on Mar West Street with downtown. (NWP.)

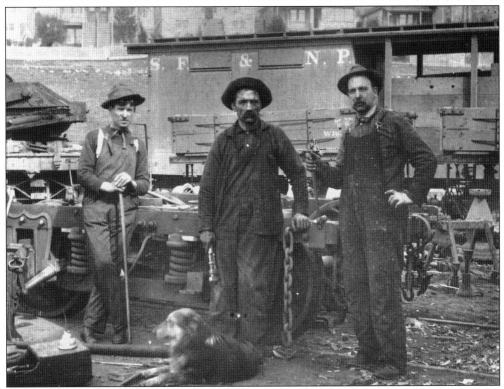

Sturdy, ready-for-anything mechanics and metal workers employed by Donahue in the Tiburon yards made and repaired locomotives and all kinds of rolling stock needed by the railroad. The largest ferry in the world, the 2,300 passenger *Ukiah*, and several others were built in the yards by these workers. (NWP.)

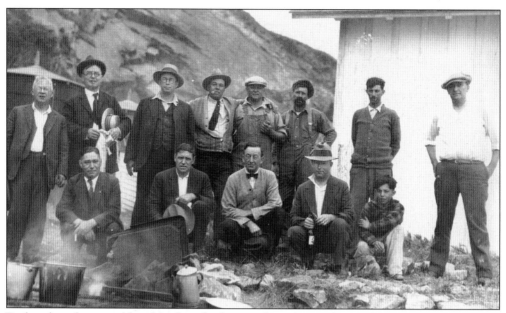

Railroad workers would gather for a barbecue when the week was done. Railroad work was hard and more than a few brews were consumed at these get-togethers. Baseball was always a popular sport in old Tiburon—many times pitting the NWP against the Tiburon Volunteer Fire Department. (NWP.)

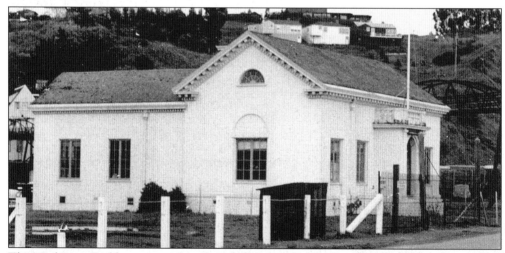

The Mechanics Building survived earthquakes, fire, and several generations of railroad workers, but it could not survive the "hippy" period of the 1960s. As soon as the NWP ceased operations, wandering youths moved in and set fires to keep warm and cook food. They so completely gutted the interior that the fire department condemned the building and it was demolished.

The commuters to San Francisco dressed well in the early days of the Tiburon service. They had a number of destinations to choose from if they headed north from Tiburon. One line went along the west coast of Marin to Pt. Reyes and Cazadero, another to Sonoma and Glen Ellen. The main line went all the way to Ukiah and Willits. (LMS Archives.)

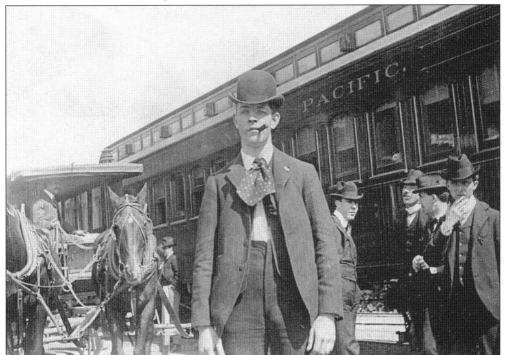

This is what the well-dressed railroad traveler would wear in 1900, even if he had to use a horse to get to the station. (NWP.)

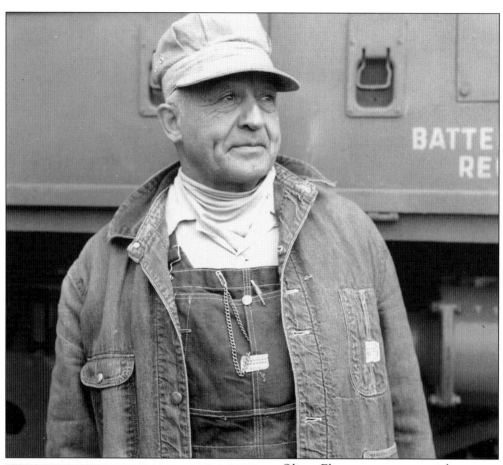

Running A
Modern Locomotive

Practical Instruction to be Combined with Actual Working
Experience. Designed for Apprentice Engineers Employed
as Student Firemen. Comprises the new Examinations
Firemen are Required to take upon the Completion of
their First Year and Second Year of Service. The
Answers are Complete and Explanatory, making
an Instructive Treatise or Post Graduate Course
of Instruction for Locomotive Firemen.

By
FREDERICK J. PRIOR

Being one of the Series of the Prior System of Self Educational
Text and Reference Books.

Issued and Published
Exclusively by the Educational Department
of the
AMERICAN JOURNAL OF RAILWAYS
AND RAILROADING
CHICAGO, ILLINOIS

Oliver Elster, an engineer and fireman, spent his working years on the Northwestern Pacific Railroad. He was never without his instruction book on how to run a locomotive. (Morrison collection.)

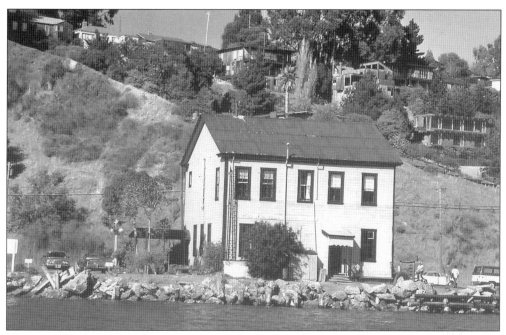

The passenger depot, dating to 1884, was saved. As part of the Point Tiburon project, the Donahue Building was deeded to the town and then leased to the Landmarks Society. A working model of the rail yards of 1909 is on the main floor.

The upstairs has been restored as the station agent's residence in the 1930s, with many pieces of original furniture donated by descendants who still live in the area.

Time Table No. 1
December 2, 1918.

	82 San Rafael Local	80 San Rafael Local	Distance from San Francisco Via Sausalito	STATIONS	Distance from Willits Via Tiburon	31 Eureka Freight	83 San Rafael Local
Daily DAY	Leave Daily	Leave Daily				Arrive Daily EX. MONDAY	Arrive Daily
			0.0	DN **SAN FRANCISCO**	137.9		
5PM	4.30PM	7.00AM	6.5	DNR **TIBURON**	131.4	2.10AM	5.40PM
				—1.0—			
	f 4.33	f 7.03	7.5	HILARITA	130.4		f 5.38
				—2.6—			
4	f 4.40	f 7.10	10.1	REED	127.8	1.58	f 5.32
				—1.3—			
5	f 4.45	f 7.15	11.4	SAN CLEMENTE (Spur)	126.5		f 5.28
				—1.3—			
5	4.52	7.22	12.7	**DETOUR**	125.2	1.50	5.23
5	4.52	7.22	14.3	**DETOUR**	125.2	1.50	5.23
				—0.6—			
0	s 4.55	s 7.25	14.9	GREEN BRAE	124.6	1.48	s 5.20
				—0.8—			
	f 4.58	f 7.28	15.7	SCHUETZEN	123.8		f 5.17
				—1.3—			
5	5.00PM	7.30AM	17.0	DNR **SAN RAFAEL**	122.5	1.35	5.15PM
				—1.7—			
			18.7	CERRO	120.8		
				—1.3—			
7			20.0	GOLF	119.5	1.15	
				—1.1—			
			21.1	GALLINAS (Spur)	118.4		
				—0.6—			
5			21.7	MILLER	117.8	**1.10**	
				—0.3—			
			22.0	ST. VINCENT (Spur)	117.5		
				—2.9—			
0			24.9	DNR **IGNACIO**	114.6	12.55	
				—2.9—			
9PM			27.8	D NOVATO	111.7	12.26	
				—3.5—			
6AM			31.3	BURDELL	108.2	**12.16AM**	

(Vertical notations: "Automatic Block" spanning the Detour–Golf section; "Double Track" spanning the Green Brae–San Rafael section.)

After leaving the Tiburon terminal in 1918, there were two more stops on the peninsula. The first was the Hilarita Station, where Hilarita Lyford owned a dairy and where the Reed School is located today. The second was the Reed Station, near today's Bel Aire, and the headquarters of the Reed dairies.

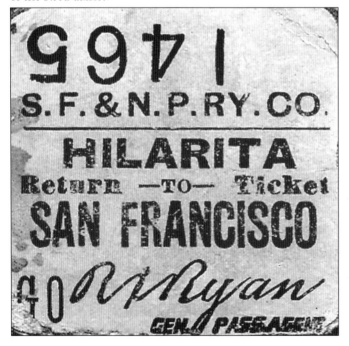

1465
S.F. & N.P. RY. CO.
HILARITA
Return —TO— Ticket
SAN FRANCISCO

In the 1890s and 1900s, riders could buy a single ticket that would get them from the Hilarita Station to San Francisco and back. One would have to change from rail to ferry to do it, but it was a lot faster than using the bridge at rush hour today. (Morrison collection.)

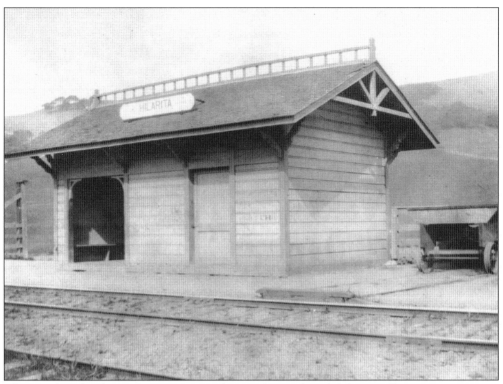

The Reed and Hilarita Stations were almost identical and did not offer many amenities. (LMS Archives.)

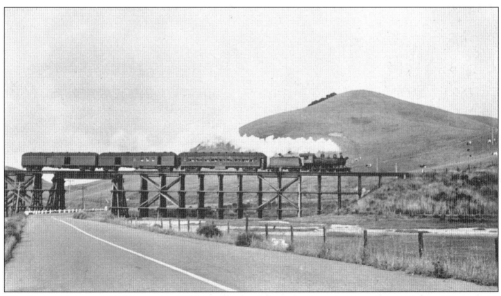

The last train out of Tiburon in 1967 was a special-excursion steam train, and thus 83 years of service to the Tiburon Peninsula came to a close. The trestle was torn down, the ferry piers pulled out, the gallows frame removed, and the right-of-way became the waterfront path enjoyed today. The railroad yards became the Point Tiburon condominiums. (LMS Archives.)

THE DONAHUE LINE

CUE: (RR MAN 4) "NOW WAIT, TELL IT HONEST. THERE WERE A FEW GOATS, TOO."

(MEDIUM 2, FOLKSY, WITH A SWING)

(RR MEN 1, 2 & 3) (ONE EACH VERSE)

1. IT W...

1 (3X)

ALL	SO	SE - RENE	JUST A	SIM - PLE	COUN - TRY	SCENE	WITH TH
2. AUGE CUT	THRU THE	HILLS	IN A	TOWN THAT	HAD NO	FRILLS	AND TH
3. HOW THE TOWN	CHEERED AND	ROARED	AND THE	CRY WAS "	ALL A -	BOARD"	AS W

For the 100th anniversary of the establishment of the Tiburon station and post office, the town held a grand celebration in 1984. Local impresario, Maria Woodward, wrote and directed a musical tribute to the railroad called *Ark Row* that featured the song, "The Donahue Line." (© Maria Woodward.)

> How the town cheered and roared
> And the cry was "All Aboard!"
> As we rode across the trestle
> By the Bay
>
> And farmer Jensen said
> As a pasture loomed ahead
> "Just remember, boys,
> The cows have right of way"
> Chorus: On the Donahue Line, on the Donahue Line

Three

FERRYBOATS

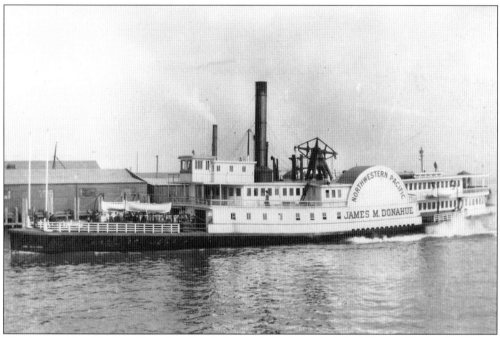

The largest island in San Francisco Bay is located off the end of the Tiburon Peninsula. Part of the Town of Tiburon, Angel Island is now a state park with thousands of visitors yearly. For over a century, it served as a military base, a quarantine and immigration station, and a POW camp. Ferry service from many ports on the bay was vital to its existence; Tiburon was closest. Until the Golden Gate Bridge opened in 1937, ferry service provided by the Northwestern Pacific Railroad was vital to Tiburon commuters who worked in San Francisco. Direct ferry service from Tiburon ended in 1909, but a shuttle to the Sausalito ferry ran until 1934. All ferry service to San Francisco from Marin ended in 1941. However in 1960, several Tiburon commuters, tired of driving, started using a private yacht to get to San Francisco. In 1962, they convinced Harbor Tours to use a sightseeing vessel for a Tiburon–San Francisco run before and after showing tourists the sights of San Francisco Bay. With modifications, the service continues today. The *James M. Donahue* (pictured above), named for the son of the president of the NWP, was built in San Francisco in 1875 and was the first to provide service to Tiburon. It was a luxurious, single-ended side-wheeler broken up for scrap in 1924. (LMS Archives.)

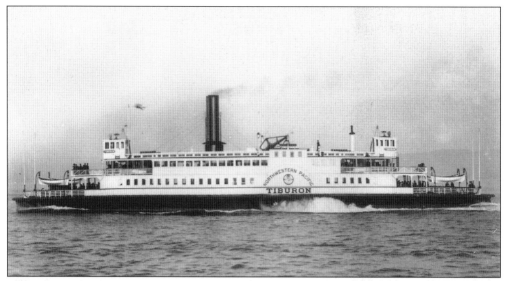

The ferryboat *Tiburon* was built in the Tiburon yards in 1884. After 40 years of service, it was broken up for scrap. (LMS Archives.)

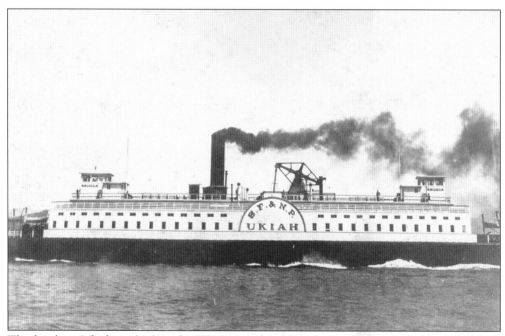

The ferryboat *Ukiah* was built in the Tiburon yards in 1891. It was the largest double-ended ferry in the world at 271 feet long and could carry 2,300 passengers and 16 railroad cars. Like all the ferries built in Tiburon, it was a double-ended, walking beam side-wheeler. (LMS Archives.)

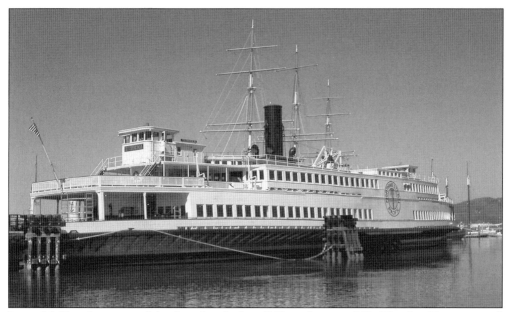

James M. Donahue, son of the founder, died in 1890 at the age of 30. The San Francisco and North Coast Railroad was sold and merged with five other lines to create the Northwestern Pacific Railroad. In 1923, the *Ukiah* was rebuilt to carry automobiles instead of railroad cars and was renamed the *Eureka*.

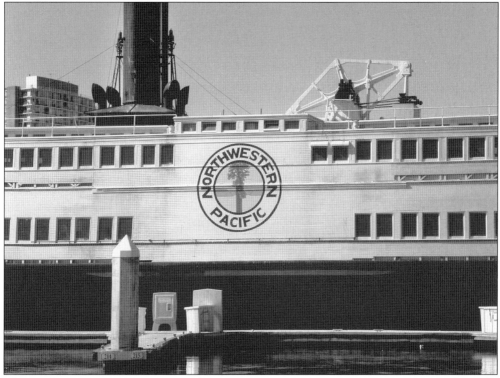

The *Eureka*, now part of the Historic Ship Collection on the San Francisco waterfront, still has the NWP logo on its side. After being rebuilt, it could carry 3,000 passengers and 100 automobiles.

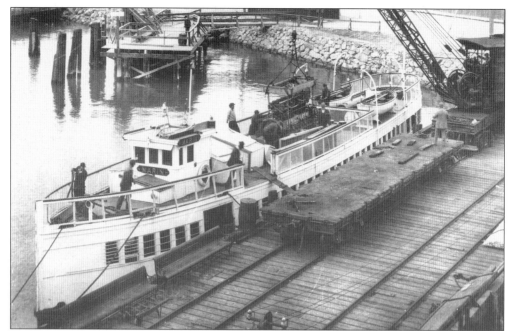

The new consortium decided to end direct passenger service from Tiburon to San Francisco. Instead they substituted the brand-new motor vessel *Requa*, which was renamed the *Marin* in 1911 after a fire. It operated as a shuttle from Tiburon, with a stop in Belvedere to meet the ferries in Sausalito. In this photograph, the *Marin* is getting a change of engines. (LMS Archives.)

The *Emperor Norton* was part of a fleet of harbor sightseeing excursion boats, including the *Harbor King* and *Harbor Queen*, operated by the Red and White (think Stanford) Fleet, which provided commuter service to Tiburon from 1962 until bought out by the Blue and Gold (think Cal Bears) Fleet in 1998.

When the Blue and Gold Fleet acquired the Tiburon to San Francisco commuter service, they replaced the old slow vessels with the high-speed, twin-hulled MV *Zelinsky* that could carry 500 passengers.

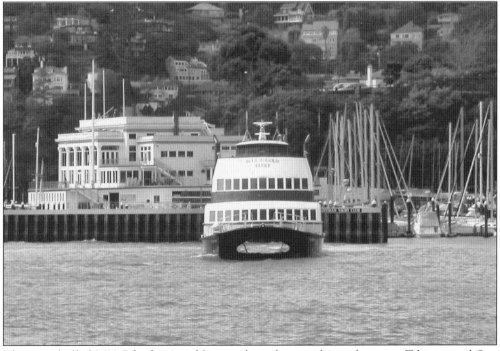

The twin-hulled MV *Zelinsky* was able to reduce the travel time between Tiburon and San Francisco. Travel times went from 30 minutes on the old side-wheelers, then to 40 minutes on the sightseeing boats, and down to 20 minutes on the catamaran. Some commuters, who had enjoyed the relaxing trip, complained that the new boats were too fast to complete card games.

Milt McDonogh, as much a fixture on Tiburon's busy waterfront as the Donahue Building or the Depot Palm, was born on one of the waterfront arks over 90 years ago. Milt's father operated a boat-leasing business from the boathouse on Main Street so Milt grew up with Raccoon Strait as his playground. When Angel Island became a state park, Milt was awarded a contract to provide ferry service from Tiburon to the island. (Angel Island Ferry Company.)

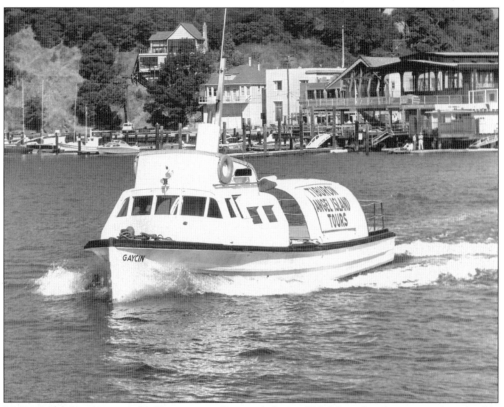

McDonogh's first ferry was the 50-passenger *Gaycin*. A former U.S. Navy shoreboat, it was inaccessible to all but the physically able and had limited space for bicycles. (Angel Island Ferry Company.)

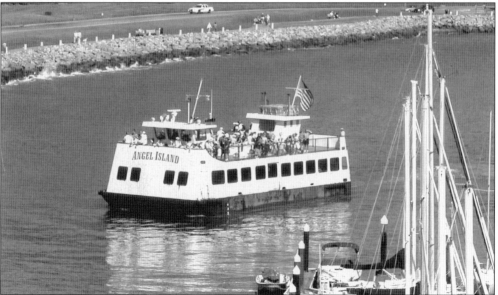

In 1974, the new *Angel Island* was put into service to handle the increase in visitors. It could carry 400 passengers, including those with disabilities, and 100 bicycles. The *Gaycin* was replaced by the *Bonita* for special excursions.

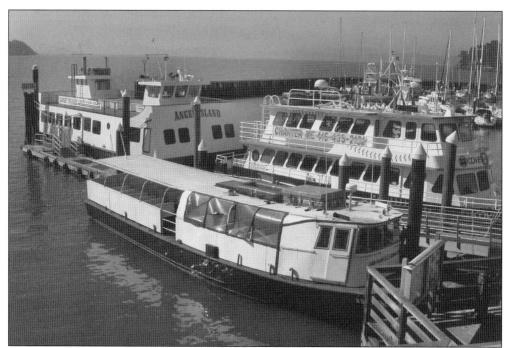

A small flotilla of ferryboats tied up at the McDonogh pier in Tiburon. After making more than 1,000 round trips a year for more than 50 years, McDonogh has turned the Angel Island Ferry Company over to his daughter Maggie and retired.

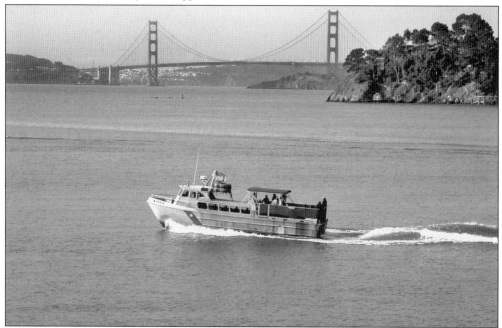

Depending on the season, a number of park employees and their families live on Angel Island. The children have to get to school, and there are no grocery stores on the island. The state park system operates this ferry on a regular schedule between Tiburon and Angel Island for park service employees and their families.

Four

THE MANY INDUSTRIES OF TIBURON

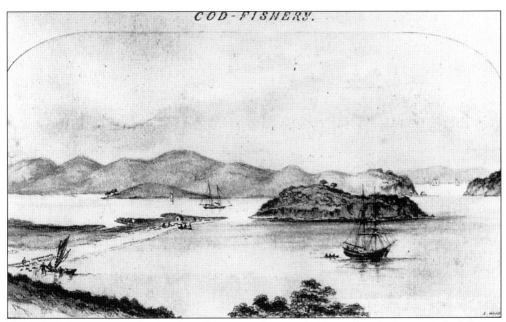

For such a compact area, the number of diverse industries that have found a home on the Tiburon Peninsula are astounding. John Reed cut timber in Tiburon for his saw mill in Mill Valley. Then came horse and cattle ranching; the dairies followed. Cod fisheries (pictured on Beach Road) were established to dry and pack fish caught in the north Pacific. Obsolete sailing vessels ended their useful service in ship-breaking yards in Tiburon. Many San Francisco buildings were constructed with bricks from Tiburon kilns. Explosives plants in Tiburon provided the dynamite to dig the tunnels and provided ammunition for the guns of the Bay Area. The coming of the San Francisco & North Pacific Railroad in 1884 had the greatest impact. With it came the shops to build and repair railroad rolling stock and to build and man the ferry boats that connected the railroad to the rest of the country. The army moved thousands of troops through Angel Island bases and the navy refueled the Pacific fleet at the coaling station on Paradise Drive. Other business were developed to serve the needs of the workers in these industries. After the end of World War II and the breakup of the Reed family properties, home building became a major industry. When the railroad ended service in 1967, closing Tiburon's biggest employer, tourism filled the gap. The shops and restaurants of Main Street changed from serving blue-collar workers to weekend visitors. Angel Island became a state park and the navy base became a world-renowned center for scientific research. (LMS Archives.)

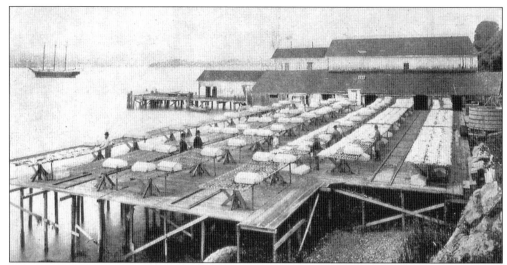

When large stocks of codfish were discovered in the Gulf of Alaska, sailing ships headed north to fill their holds. The fish were salted to preserve them for the trip to Tiburon. On arrival, the codfish had to be washed, dried, and packed for sale throughout the country. The first codfish packing plant was established on Beach Road (see the drawing on page 45), followed by this one on West Shore Road. Another large plant was at the future navy base on Paradise Drive. (LMS Archives.)

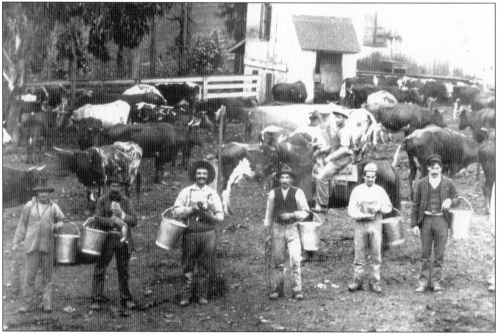

Horses, leather, and tallow were the main ranch products in the early days. Mexican cattle were not good milkers, so as soon as possible, the Reeds sent for the best dairy cows in England. Dairies were established at the Big Reed Ranch (near Bel Aire), the Little Reed Ranch (Del Mar School), the Hilarita Dairy (Reed School), and the Eagle Dairy (Harbor Point Tennis Club). Portuguese workers were also imported to produce some of the finest butter, milk, and cream in the Bay Area. (LMS Archives.)

The aptly named Hazard Powder Company, and others, found the remoteness of the Tiburon Peninsula an advantage in their dangerous business. As late as World War II, the U.S. Army planned to construct a rail line from Corte Madera to Paradise Cove and to build loading docks for ammunition there. This required the evacuation of all residences on the Tiburon Peninsula east of Highway 101. Construction had begun, but the war ended just in time. (LMS Archives.)

The Belvedere Garage was originally located on Beach Road. As Main Street became the business center of peninsula life, the garage moved as well and was located where the street turns into Ark Row. (LMS Archives.)

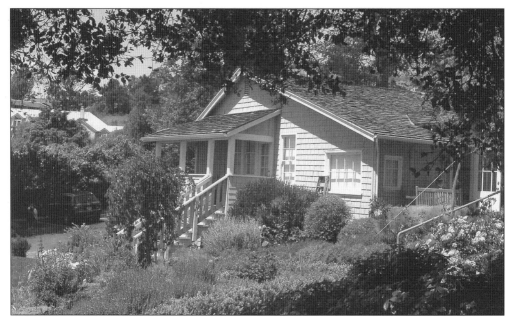

A brick kiln located near the Hilarita Dairy was one of several on the peninsula producing building materials. The original one-room bunkhouse for kiln workers was enlarged to accommodate farm families living there after the kiln closed. In 1944, it became the private residence of William and Helen Newman, who lavished time and skill into creating beautiful gardens. They bequeathed the property to the Landmarks Society, who have restored both the house and the gardens.

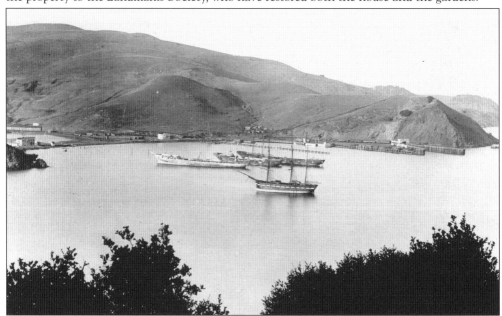

Several generations of maritime history awaited destruction at the ship-breaking yards in Tiburon in 1886. Steam-powered vessels replaced the grand clipper ships that had gained American dominance in world commerce. Propeller propulsion soon made the side-wheel ships that replaced them obsolete. Many cabins and other parts of these ships were salvaged to become arks or outbuildings on the peninsula. (LMS Archives.)

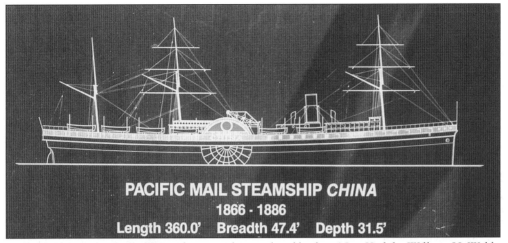

PACIFIC MAIL STEAMSHIP *CHINA*
1866 - 1886
Length 360.0' Breadth 47.4' Depth 31.5'

In 1886, the wooden-hulled S.S. *China* was designed and built in New York by William H. Webb. This side-wheeler made 30 round-trip voyages between San Francisco and Yokahama before steel-hulled, propeller-driven ships made it obsolete. Its beautiful social cabin was saved and for 90 years was a private residence on Belvedere Cove.

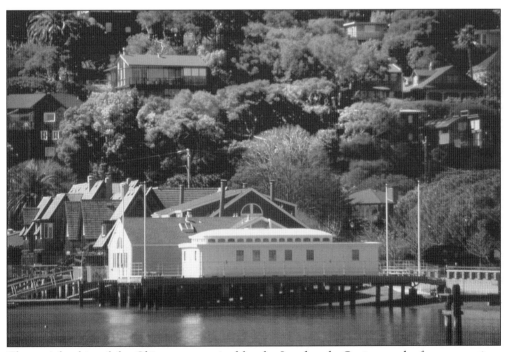

The social cabin of the *China* was acquired by the Landmarks Society and, after restoration, placed on its own pier over water on Beach Road in Belvedere.

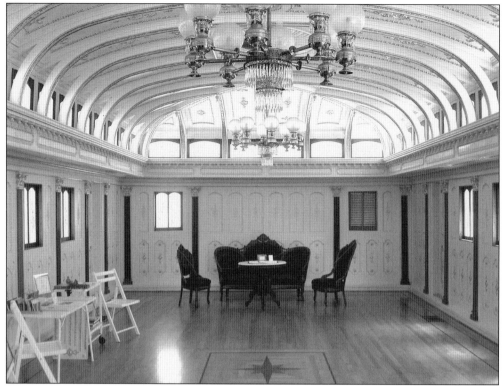

The beautifully restored China Cabin is open to the public on Wednesday and Sunday afternoons during the daylight savings period. It is also available for meetings and receptions.

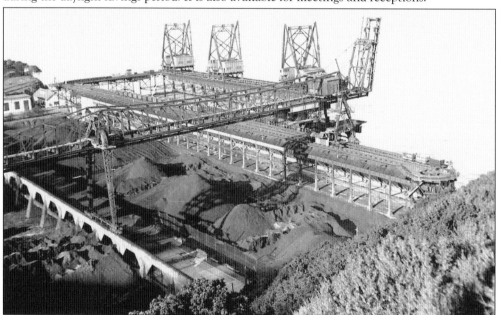

The U.S. Navy ran on coal when steam replaced sails. Colliers, equivalent to today's tankers, brought coal in bulk from the East Coast to Tiburon. Ships of the Pacific Fleet would refuel at the U.S. Navy Coaling Station in Tiburon. (Romberg Center.)

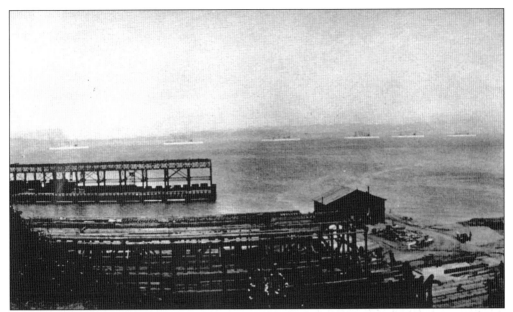

In 1908, Pres. Theodore Roosevelt's Great White Fleet, consisting of 16 battleships with support vessels, made a lengthy stopover in San Francisco Bay on its trip around the world. This photograph shows the fleet lined up off of the Tiburon Peninsula waiting to fill their bunkers with coal. (LMS Archives.)

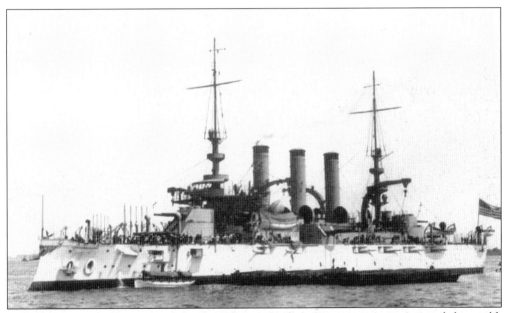

The battleship *New Jersey* stands by the Tiburon Coaling Station on its trip around the world. President Roosevelt wanted to show the globe that the United States was a world power, although a peaceful one. He sent the fleet around the world, stopping in many ports to greet the local populace.

The coaling station closed when the navy switched to oil to fuel their ships. It was later, briefly, the home of the California Maritime Academy. In the 1930s, the contractors building the Golden Gate Bridge used the site for a supply depot. The main vertical suspender cables were spun at the site before being barged to the bridge and lifted into place. (Romberg Center.)

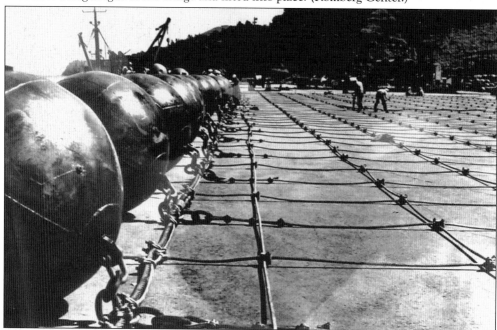

As World War II loomed, it was determined that a seven-mile-long steel net was necessary to keep enemy submarines out of San Francisco Bay. The former navy coaling station became the U.S. Navy Net Depot, Tiburon. More than 20 types of harbor nets and booms were constructed at the depot for use throughout the Pacific theater. (Romberg Center.)

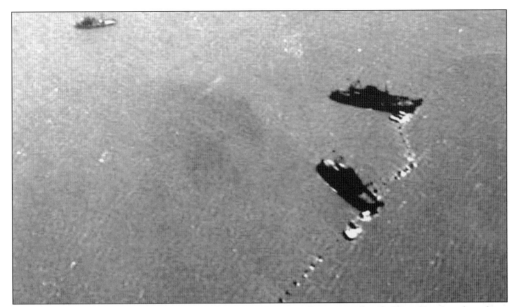

This is a rare photograph of the net tenders maneuvering the net at the Golden Gate so that ships could enter and leave the bay. Nets from Tiburon protected the harbors from Seattle to Sydney. Some were huge, like San Francisco's, some had mesh screening to keep out torpedoes as well as submarines, and some were simply floating booms to protect against small, fast torpedo boats. Not only were the nets manufactured at the Tiburon base, but crews were trained there in the handling and use of the nets. (LMS Archives.)

The larger nets were held down by large blocks of concrete like these. After the war, many of the nets came back to the Tiburon station for dismantling and disposal. The steel was cut up for scrap, and these blocks made great rip-rap to protect the shoreline. They can still be seen along Paradise Cove.

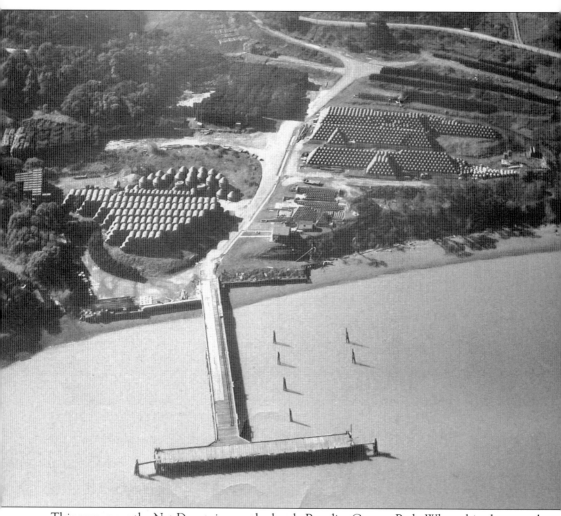

This cove, near the Net Depot, is now the lovely Paradise County Park. When this photograph was taken, it was the main port of supply for the floats that held up the anti-submarine nets. However early in World War II, the enemy captured all of the shipyards west of Pearl Harbor, and the navy was about to send thousands of ships in harm's way. The solution was to build floating dry docks and bring them to Tiburon. Here men were trained in the operation of three sizes of floating dry docks that, when paired with navy repair ships, could handle anything from a PT boat to an aircraft carrier in the most remote part of the Pacific. Almost all were armed with antiaircraft weapons and participated in landing operations and ship defense with the fleet. (LMS Archives.)

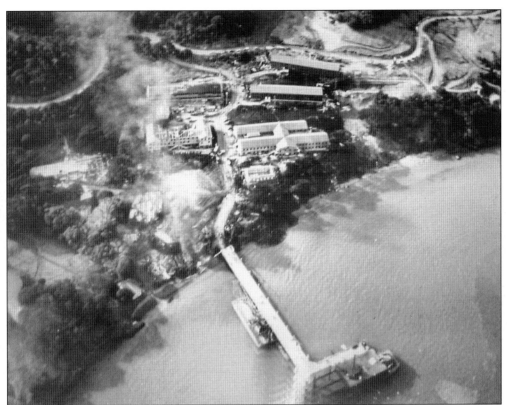

The former supply port for the Net Depot changed quickly into the U.S. Navy Floating Dry Dock Training Center, with barracks and support buildings for 3,000 men. Some of the floating dry docks were small and self-propelled. Others were large and had to be towed by tugs to battle zones. The largest came in sections, which had to be towed out to sea and joined together to handle the big ships.

The Floating Dry Dock Training Center had its own post office and cancellation stamp. (Morrison collection.)

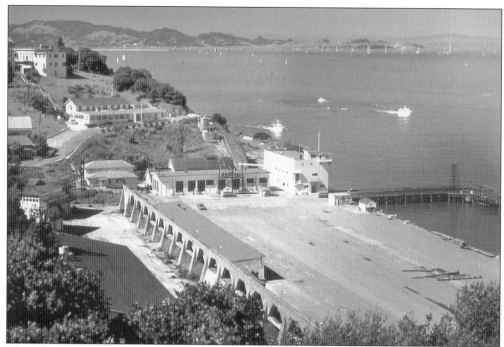

The Tiburon Naval Net Depot finally closed in the 1960s, and the property became the home of several research vessels of the Bureau of Mines and Fisheries and the National Oceanic and Atmospheric Administration. Now the Romberg Tiburon Environmental Center, it is a branch of San Francisco State University. Primarily involved with estuarine research, the center brings students together with faculty and experts from around the world. Their research vessels have this as their home port.

The Tiburon Post Office had two faithful workers in 1959. Claudine Anderson was the postmistress, and Fleeta Foster was the only other employee. There was no mail delivery, only post-office boxes, and the post office became the center for meeting friends and exchanging gossip. (LMS Archives.)

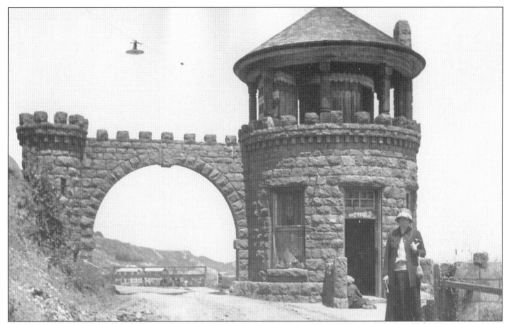

Home construction has been a slow but continuing industry on the peninsula. The first subdivision was started by Dr. Benjamin Lyford. He called it Lyford's Hygeia after the goddess of health. Dr. Lyford envisioned the project to be a great sanitarium or resort, the finest in the world and "free from fogs and malaria." He built a grand entrance to the subdivision. The arch was later removed to widen Paradise Drive. The tower remains. (LMS Archives.)

While Lyford's Hygeia was not a success during Dr. Lyford's lifetime nor is it the resort he had dreamed of, it has gradually become Old Tiburon, or Lyford's Cove, one of Tiburon's most popular neighborhoods.

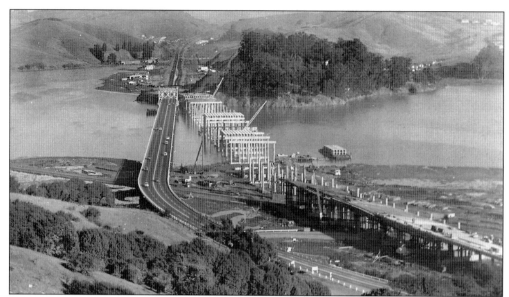

The widening and elevation of Highway 101 and removal of the drawbridge over Richardson Bay in the 1950s was a major construction project that influences life on the peninsula even today. It has been widened several more times and might be once or twice again.

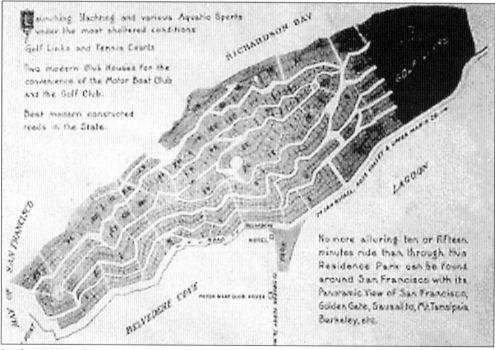

In the 1880s, a lawyer, Thomas B. Valentine, solved the Reed's problems with the U.S. Land Commission and received two small islands in lieu of fees. One he named Valentine Island (known as Corinthian Island); the other he sold to the Belvedere Land Company, which he founded in 1890. This early Belvedere subdivision map included a nine-hole golf course. In 1935, Harry Allen, the developer of Sea Cliff in San Francisco, acquired controlling interest in the Belvedere Land Company, and his family continues to manage the properties. (LMS Archives.)

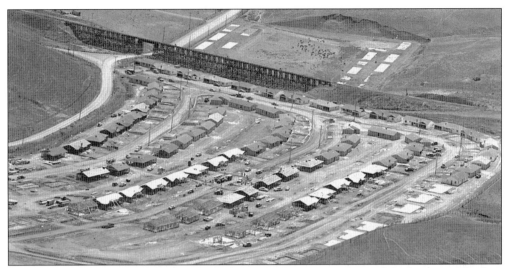

The breakup of the Reed Ranches coincided with the postwar demand for housing. The first serious development came in the 1950s, when Joseph Eichler covered the north part of Strawberry with his distinctive tract houses. Belveron Gardens, on both sides of the NWP trestle, followed soon after.

Three-bedroom houses selling for $12,500 were snapped up by returning GIs as fast as they could be built. The 1956 Marin County Master Plan for the Tiburon Peninsula envisioned the type of development in this aerial view covering all the open land. The successful incorporation of the City of Tiburon ended that idea. Today, with few sites available, construction on the Tiburon Peninsula is confined to remodeling; "tear down" sites sell for more than $1 million.

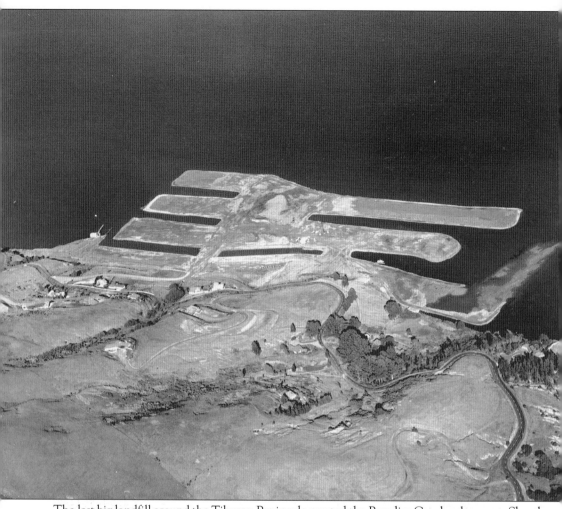

The last big landfill around the Tiburon Peninsula created the Paradise Cay development. Shortly after this fill was finished, the San Francisco Bay Conservation and Development Commission came into being with instructions that "there shall be no use in the bay for which an alternative upland location is available." Nevertheless beautiful homes, most with their own dock, now line the shores of Paradise Cay. The Tiburon Yacht Club is located here.

Five

DOWNTOWN

The primary business districts of Belvedere and Tiburon are at the extreme southwest end of the Tiburon Peninsula—where land meets water. The legal boundary between the two cuts through many buildings. Jeanie, in her popular Jeanie's Java on the Boardwalk, stands in Belvedere while pouring coffee for customers in Tiburon. The Corinthian Yacht Club is mostly in Belvedere, while their entrance, parking, and most of the yachts are in Tiburon. Fortunately few people care any more. Two companies own most of the buildings in downtown. The Belvedere Land Company owns the Boardwalk and the apartments and offices on Beach Road. Main Street Properties owns almost everything else on both sides of Tiburon Boulevard, plus Main Street and Ark Row. The owners of both companies have been involved with developing the business district for decades and are quite concerned that it continue without major change.

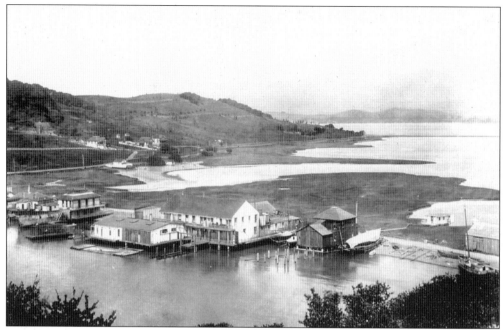

Originally the only way into downtown was via the sand spit, now San Rafael Avenue, along the shore of Belvedere Island, then via the sand spit that became Beach Road, to Main Street in Tiburon. This c. 1890 scene looks from Corinthian Island over Beach Road to the partially silted lagoon and the tip of Belvedere Island where the golf course was located. (LMS Archives.)

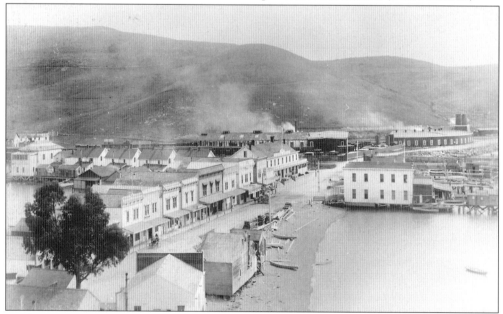

By the 1890s, Main Street began to grow into the primary business and shopping area of the community. The large white building on the water is the boathouse and is the only surviving structure from this period. It has undergone many remodels and now has a false facade. At the far end of Main Street is the Sonoma Hotel and four railroad worker dormitories barged down from Donahue Landing. (LMS Archives and State Library.)

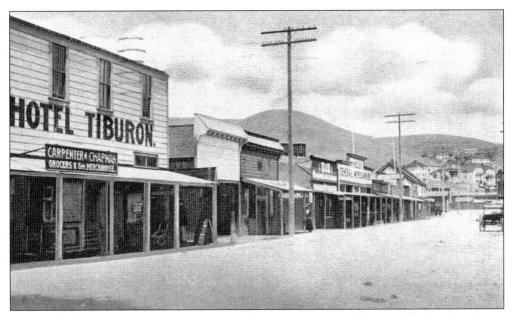

Hotels, boardinghouses, and saloons on Main Street were complemented by butcher shops, livery stables, and the ferries. Fresh vegetables that came over on the morning ferry from San Francisco were delivered directly to the home by a Chinese merchant. During the early days, soldiers, sailors, dairy, and railroad workers filled Main Street shops, bars, and other places of entertainment. (Morrison collection.)

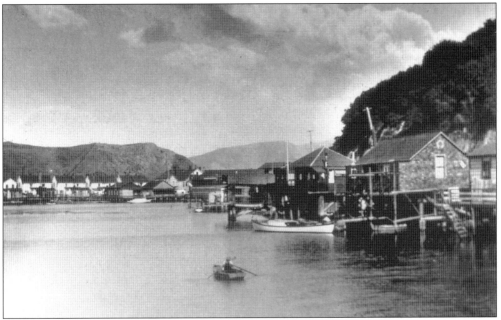

In 1890, it was still possible to row a boat through the lagoon that has now become the parking lot by the Tiburon Playhouse. The rooming houses from Donahue Landing can be seen on the far left in this photograph. The lagoon was gradually filled in (with some help); old arks and some cottages were raised on pilings; and the Ark Row extension to Main Street was created. (LMS Archives.)

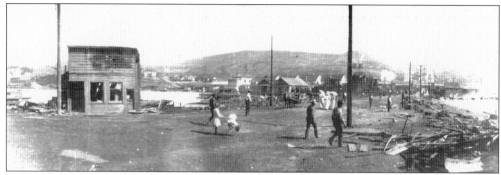

Main Street was only a memory after a great fire in 1890. It started in the back of William O'Connor's Tiburon Hotel and did not go out until it ran out of buildings to burn. Fire crews from the railroad yards set up bucket brigades in a futile attempt to extinguish the blaze. The railroad company opened passenger cars and provided blankets to those made homeless by the fire. The ferry *James M. Donahue* ran aground attempting to approach Main Street from the water side and was rendered useless. (LMS Archives.)

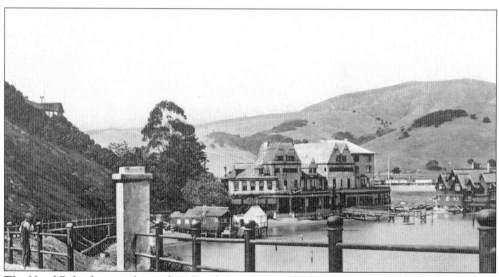

The Hotel Belvedere was located on Beach Road where the San Francisco Yacht Club later built their clubhouse. The hotel opened around 1899 and closed 25 years later. For a while, it hosted Belvedere social events, but in spite of $3 room rates and hot and cold water in every room it was not a financial success and was torn down. (Morrison collection.)

One of the early businesses in downtown Tiburon was a yacht supply company in the Kelly Building. Besides sailing, the horse was still the primary means of transportation. (LMS Archives.)

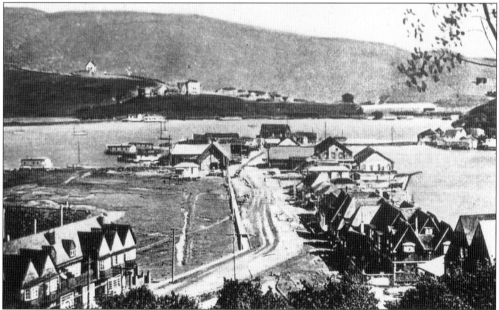

Beach Road, besides being the connecting link to Main Street in Tiburon, was also the primary shopping street for Belvedere. In the early days, the Belvedere Land Company building, seen at left in this photograph, served as the town center, with a library, a medical office, a grocery, a drugstore and soda fountain, and the telephone exchange. (LMS Archives.)

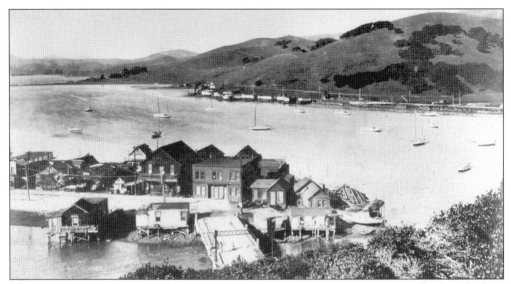

Where Beach Road turned into Main Street a drawbridge opened twice a year to let the arks from Belvedere Cove pass into sheltered waters for winter and then back out in spring. This was the beginning of the "Opening Day" tradition. After the drawbridge was replaced by a fixed span, the Corinthian Yacht Club revived the tradition as the official opening day of the yachting season on the bay. (LMS Archives.)

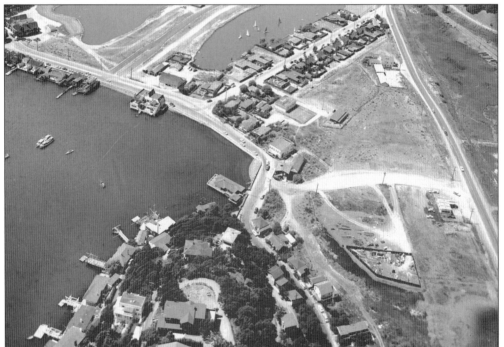

Folks did not wait for Beach Road to be extended to meet Tiburon Boulevard, which was finally completed in 1930. An informal connector was still in use in the 1950s. Several arks were eventually moved out of the way, the road paved, and the Boardwalk built, straddling the dividing line between the two communities. Travelers to Main Street no longer had to negotiate the circuitous trip around Belvedere to get downtown. (Morrison collection.)

Architect Albert Farr designed the Belvedere Land Company building on Beach Road in 1905. The next year he designed a group of townhouses, still called the Farr Cottages, next to the Belvedere Hotel. He set the standard for design in Belvedere.

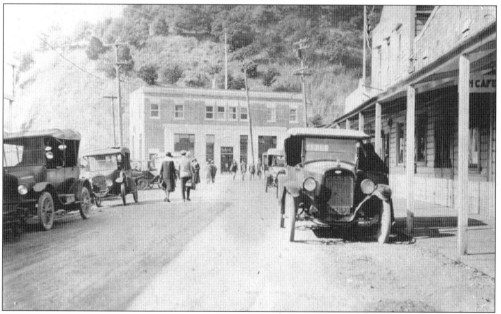

By 1925, the brick bank building at the end of Main Street had appeared along with Model T and Model A Fords and other vintage automobiles. American Savings and Loan operated a branch there and, from 1929 to 1950, it was the home of the Tiburon Library. Main Street was a bit too disreputable for Belvedere matrons, so they established a "reading" room in the back of the Land Company offices. (LMS Archives.)

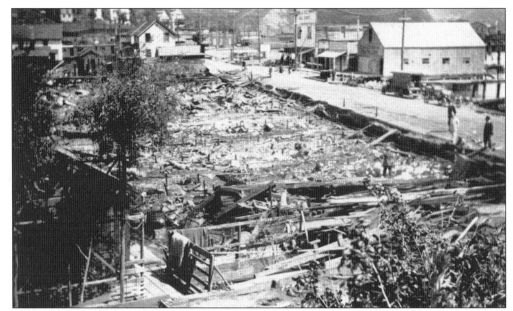

The second great fire on Main Street occurred on April 4, 1921. It started in the back of Sullivan's Saloon, or Sullivan's Ice Cream Parlor as it was called during Prohibition. The bartender at Sullivan's admitted at the fire marshal's inquest, "I had a powerful mash brewing in my still and it blew up and burned down the whole . . . town, ain't no mystery." Railroad crews again fought a losing battle trying to save buildings made out of matchwood. The ferry *Tamalpais* rushed eight firemen and a pump over from San Francisco, but to no avail. With few exceptions, the buildings on Main Street today have been built since 1921. (LMS Archives.)

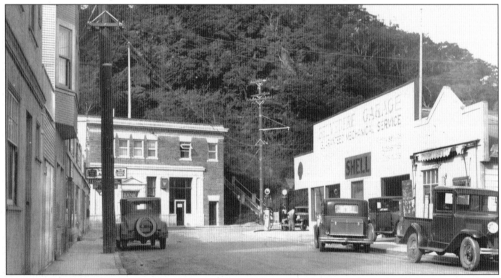

By the 1930s, Main Street had become the peninsula's "downtown." The Belvedere Garage, which had been on Beach Road, relocated to Main Street, replacing livery stables. The Tiburon Library moved into an ark beached in the lagoon. Anderson's butcher shop, the Corner Market, Musso's bakery, and a taxi service took care of most needs so that residents did not have to leave the peninsula. The bars and restaurants were not the glamorous ones that would come later—Tiburon was still a blue-collar town. (Morrison collection.)

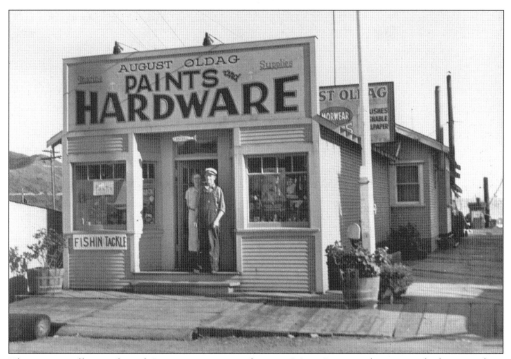

There were still a number of community-serving shops on Main Street as the peninsula demographics changed. "Gus" Oldag and his wife ran a marine hardware store on Main Street for many years. Fishermen could stop and pick up tackle and bait before going next door to McDonogh's and renting a fishing boat for the day. (LMS Archives.)

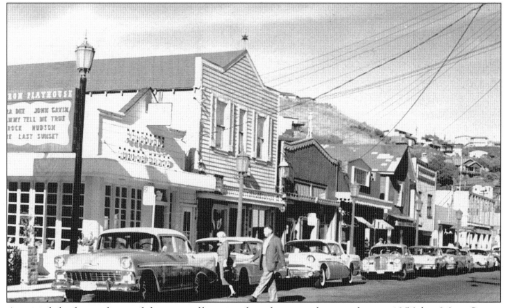

Automobiles have changed dramatically since this photograph was taken in 1956, but Main Street was beginning to take on the look that would remain to the present. Fred Zelinsky, a weekend resident and head of the world's largest painting company, purchased most of the buildings on Main Street and Ark Row and set out to preserve their historic look. (Morrison collection.)

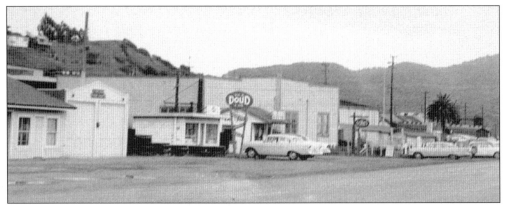

Tiburon Boulevard in the 1950s and 1960s looked the part of a dying railroad town. The oversized warehouse building was turned into an indoor "flea market," known as the Pandemonium. The only survivor in this photograph is the small white building next to the warehouse, which was a self-service laundry. A careful look at the photograph will reveal a small palm tree in the right-hand corner.

Every passenger station in the Northwestern Pacific system had a palm tree planted nearby. Tiburon was no exception, although by 1960, its surroundings had deteriorated to being a parking lot for old cars.

In 1985, as part of the Point Tiburon development in the former railroad yards, the Depot Palm was given a new, elegant home at the intersection of Main Street, Paradise Drive, and Tiburon Boulevard. It is one of Tiburon's treasured links to its railroading past.

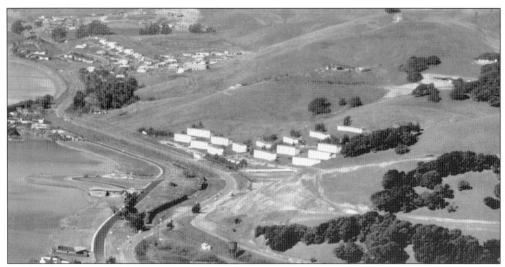

In 1942, Hilarita housing was built near downtown to house military families stationed at peninsula navy bases. After World War II, it was leased to the Marin County Housing Authority and then to the Ecumenical Association for Housing. When it was rebuilt in the late 1970s, the two lower buildings were purchased by the Town of Tiburon and became the town hall and police station for the next 17 years.

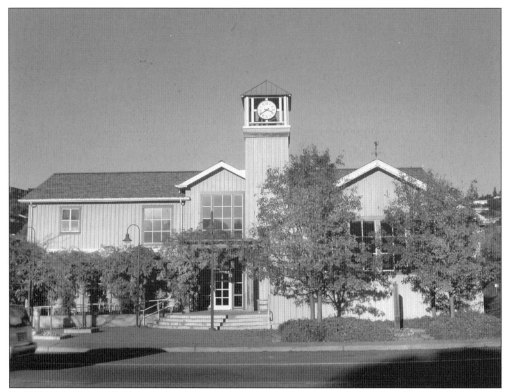

In 1997, the Town of Tiburon finally got a permanent downtown home for offices and a council chamber. The former town hall site was sold to create the Chandler Gate condominiums. The police department remained at Hilarita but in a new building after 1999.

Robert (Bob) Kleinert came to Tiburon in 1970 as assistant city manager, became city manager in 1973, and retired as town manager in 2000—a very unusual length of service in Marin County. When he started, town hall was in rented quarters on Ark Row. A few years later, it was moved into a drafty World War II barracks building left over from the Hilarita housing project. Finally in 1997, Bob's dream came true, and he was led in a parade of former mayors and councilmen he had served to a new office in the new town hall. He is pictured here in his old office before the building was burned down.

Lou Brunini was the first superintendent of Public Works after the incorporation of Tiburon in 1964. He held this position until he retired in 1990 and then continued as a part-time "advisor" until his death in 2005. His pickup, "Betsy," was the first purchase by the new city and was given to Lou upon his retirement so that he could continue cruising the streets of Tiburon with his familiar smile, looking for and fixing problems, rain or shine. (Diane Smith.)

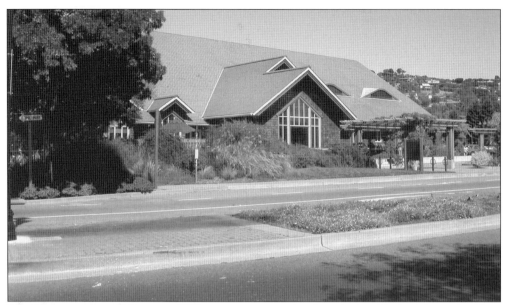

The first community library in 1895 was, appropriately, aboard a landlocked ferry, the *Flora Temple*, on Beach Road in Belvedere. In 1929, a branch of the county library was opened in the bank building on Main Street in Tiburon, but Belvedere wanted its own library, so in 1931 there were two. In 1950, the Tiburon library moved to a landlocked ark next to Main Street. In 1953, the two became one again and after several more moves, opened this new Belvedere-Tiburon Library on Tiburon Boulevard in 1997.

The Chandler's Gate condominiums rose on the site of the old town hall next to the Hilarita complex.

The first Tiburon Post Office arrived with the railroad in 1884. Belvedere got its own post office when the Land Company finished its building on Beach Road. The two were combined into the Belvedere Tiburon Post Office in 1956 and moved into this new building on Beach Road in Tiburon. In 1997, the library moved out and the post office expanded into its present location. The zip code 94920 serves most of the Tiburon Peninsula, regardless of political jurisdiction.

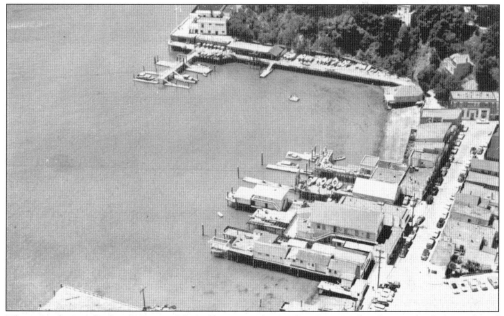

This aerial view looks down on Main Street in the 1950s. Sam Vella's house, built by railroad carpenters in 1924, was in the middle of what was to become the Corinthian Yacht Club parking lot. It was later moved onto Corinthian Island behind the bank building. Most of the open water in this photograph has been filled with slips and piers for yachts and ferries.

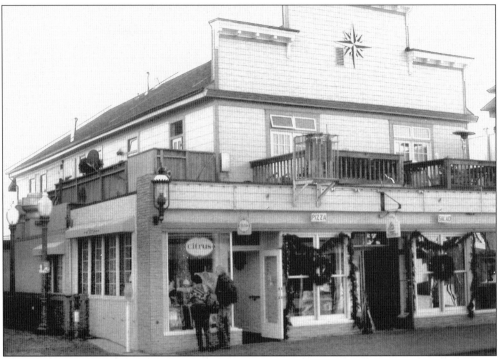

The old boathouse is Main Street's oldest building. It has survived both fires and the ravages of time and has a new facade and a new pizza parlor inside. After World War II, Main Street started to reflect the changing character of Tiburon. The railroad was shutting down, and the hills were blossoming with suburban houses. Shopping malls along Highway 101 provided the necessities; Main Street provided the extras and began to appeal more to tourists than residents. (Morrison collection.)

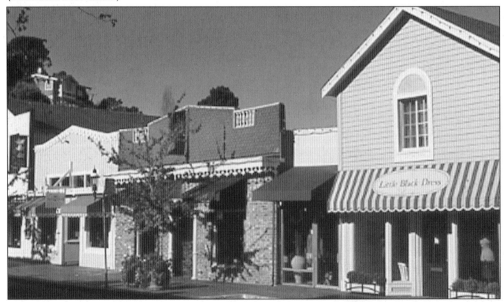

Some communities have their "magnificent mile" retail districts. Tiburon's is only 475 feet long, but it is still flooded with visitors whenever the sun shines and the ferries are running.

"Quaint" is the word often used to describe Main Street, and to some, it looks like a movie set. However it is still "downtown" to the citizens of Belvedere and Tiburon, and they fight to preserve its character.

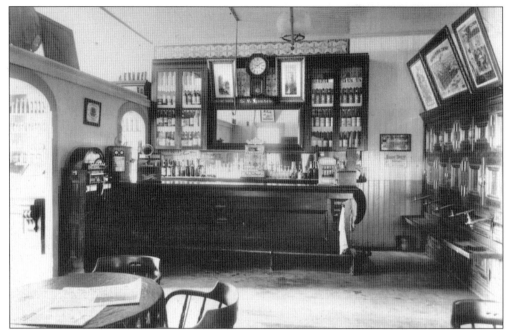

Places of entertainment have been popular on Main Street since the earliest days. While a little more subdued during Prohibition, they still operated openly. Some on the waterside had the advantage of trapdoors, which fast boats operating from Canadian ships offshore could use to unload their merchandise without being caught. (LMS Archives.)

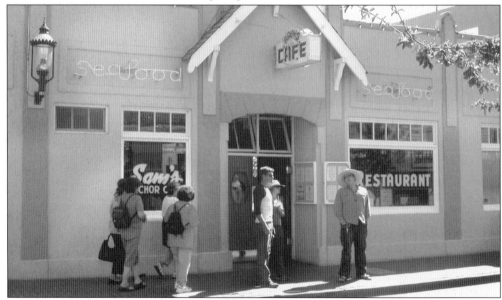

Sam's Anchor Café, pictured above around 2000, has operated on Main Street since about the end of World War I; Prohibition did not slow it down one bit. Like most of the saloons on the waterside of Main Street, they had a trapdoor to load booze from small boats shuttling to Canadian ships stationed outside the Golden Gate. With cooperative Northwestern Pacific Railroad telegraphers watching most access routes to Tiburon, the saloons would be holding prayer sessions by the time any revenuers got to town for a raid.

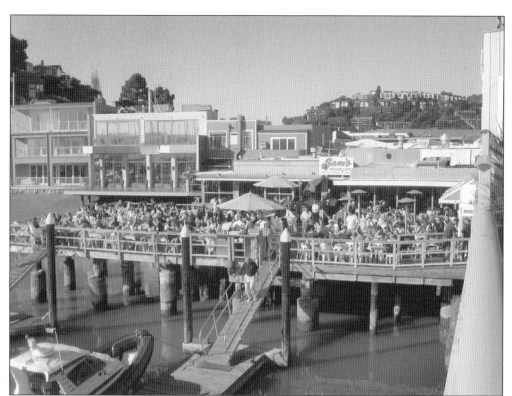

Sam's deck is still one of the most popular places in town for locals and tourists. The food is great and everybody has a good time. Sam's deck, on a sunny Saturday or Sunday, is *the* place to be, not just to be seen, like some posh spots across the bay. Many just enjoy the food, wine, and good fun.

Sam Vella was an immigrant from Malta, a restauranteur, a barkeep, a bootlegger, and a scoundrel. Yes he was all those things and also one of the more colorful characters on Tiburon's Main Street. Sam's Anchor Café has outlived him by almost half a century and continues to be one of the most popular eating and drinking establishments on the bay. (Morrison collection.)

Sam's Glockenspiel Band led the frequent parades down Main Street. (Morrison collection.)

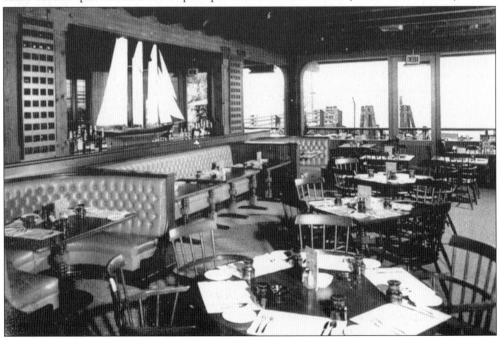

Another popular restaurant on Main Street in the 1960s and 1970s was the Windjammer. With nautical décor, it fit in with the incredible view of San Francisco Bay. It is now, however, Guaymas, an elegant Mexican restaurant. (Morrison collection.)

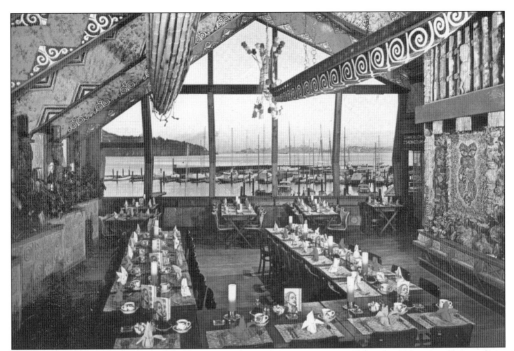

Tiburon Tommie's, in spite of its pseudo-south seas look and Cantonese food, was a popular Main Street restaurant and meeting place for decades. Beyond repair, it was demolished after 2000 and has been replaced by apartments and shops. (Morrison collection.)

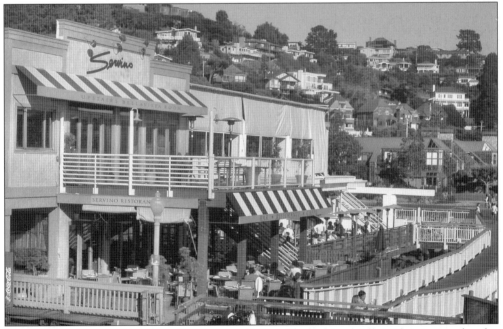

The building housing Ristorante Servino was designed by architect Allen Thompson, who also served on several Tiburon boards and commissions. It was Thompson who devised the walkway that opened up the waterfront without blocking the view from the adjoining restaurants. After his death from ALS, the town named it the Allen Thompson Walkway.

Fred Zelinsky, pictured here with daughter-in-law Laleh, bought most of downtown Tiburon when the buildings were rotting away and the lagoons had become mosquito-breeding swamps. Fred and his wife, Juanita, used the China Cabin as their weekend residence while Fred played benevolent landlord to struggling businesses in his beloved Tiburon. His frequent appearances before the town council to change or modify his properties were special occasions. Fortunately his company, D. Zelinsky and Sons, was the largest painting contractor on earth. (Zelinsky family.)

The late Edward G. Zelinsky followed his father in the management of Main Street Properties. Ed, with his sister, Barbara Abrams, owned most of the Tiburon business district following the deaths of their parents. Property that had not yet been developed was donated to the community for the new Belvedere-Tiburon Library and the Tiburon Town Hall. Besides his business interests, Ed was also a maritime historian interested in recovering and restoring old ships. (Zelinsky family.)

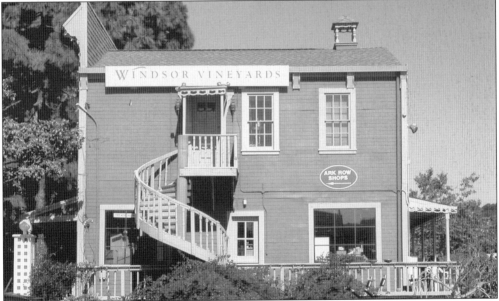

Ark Row was a particular passion for the Zelinskys. Many of the arks that wintered in the lagoon behind Main Street gradually were elevated on pilings and turned into shops or houses. As the lagoon was filled to become a parking lot, the space under the arks became offices and small shops. The former Fleming Rooming House, pictured here, was never an ark, but some suspect it was moved to Ark Row from Tiburon Boulevard at some time in the past, perhaps even from Donahue Landing.

Not all the shops on Ark Row are vintage arks. Built in 1968, 80 Main Street was built for use as the first town hall of the newly incorporated Tiburon. Offices were on Ark Row, and the council chambers and police station were on the lower level. When the town offices moved to Hilarita in 1980, the space was converted to shops and offices.

Ed Zelinsky was also a collector of vintage automobiles and motorcycles. Ed's Garage, where he kept and displayed several vehicles, was located on the lower level of Ark Row, with several old arks at street level in front.

This is another example of Ark Row arks facing Main Street on top with a restaurant or other business on the parking-lot level.

A popular coffee shop in the railroad days was Agnes's diner, which is now the New Morning Café. Commuters waiting for their ferry would mingle with industrial workers on their way to work in the NWP shops. Laptop computers are more common than lunch buckets these days.

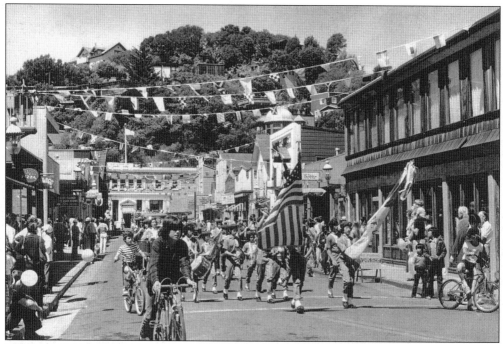

Tiburoners love a parade. They used to parade down Main Street just to celebrate the opening of the draw bridge so that the arks could move to shelter for the winter. This parade in 1976 celebrated the bicentennial of the United States. (LMS Archives.)

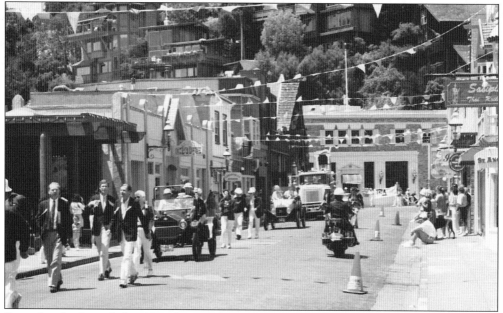

Seven hundred paraded in 1984 for a triple anniversary for Tiburon. It was part centennial, for in 1884 the railroad came to town and a Tiburon post office was opened. The celebration also marked the 20th anniversary of the incorporation of Tiburon. The parade was the start of a weeklong party, including dinners, showing of old home movies, a jazz festival, and a new theatrical production by Maria Woodward, called *ARK ROW*.

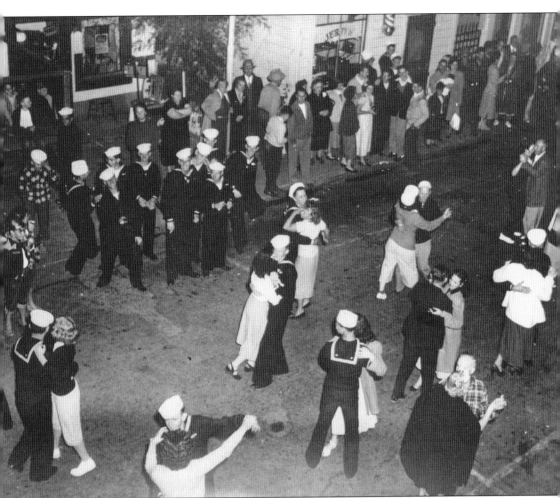

Soldiers and sailors stationed in Tiburon during World War II flocked to Main Street on weekends. The young ladies of Belvedere and Tiburon were not going to waste the opportunity. Impromptu street dances were held until the war was over. (LMS Archives.)

In 2005, the citizens of Tiburon reclaimed Main Street, at least on Friday nights. The restaurants moved food service out to the curb, and it became a big block party reminiscent of the World War II weekend parties but without all the sailors.

Dominating the Tiburon waterfront in the post-railroad era are the luxury Point Tiburon condominiums built in the old NWP railroad yards.

Six

RECREATION

To some people, the Tiburon Peninsula is just one big playground with miles of waterfront available to the public and a 900-acre wildlife preserve, a mile-square state park, three world-class yacht clubs, four tennis and swimming clubs, hundreds of acres of open hills to hike, miles of paved bicycle trails, and views of bay and bridges from every high point. Funky Main Street and elegant Point Tiburon attract both residents and visitors looking for a good time. This did not just happen. The Tiburon Peninsula was blessed with an unmatched geographical setting and a history worthy of preserving. An engaged citizenry made sure it was protected. The departure of the Northwestern Pacific Railroad in the 1960s provided the spark to makeover the landscape of downtown and the waterfront and at the same time, preserve the history of the Peninsula and its settlers, workmen, ranchers, and saloon keepers.

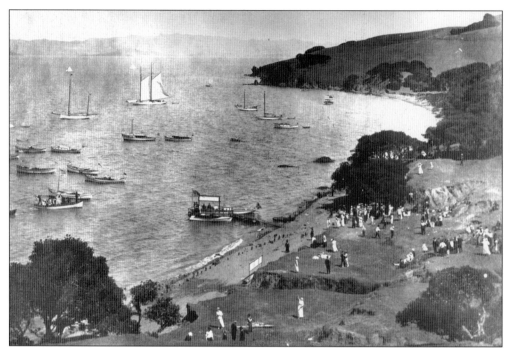

In the early 1900s, the San Francisco & North Pacific Railroad ferries were busy during the week hauling freight cars and passengers between Tiburon and San Francisco. To keep them working on weekends, the railroad established a resort named El Campo on Paradise Cove for the "respectable section of the picnic community." Since it was only accessible by the SF&NPRR ferries, El Campo was protected from "San Francisco ruffians" whose main pleasure was disrupting family outings in Marin. (LMS Archives.)

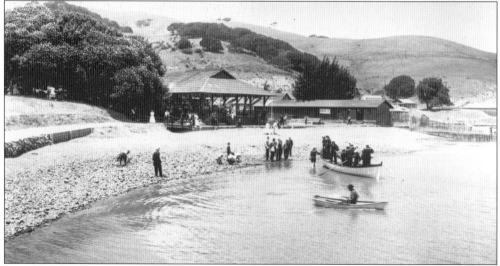

El Campo was so popular that throngs lined the San Francisco docks on weekend mornings waiting to get aboard, according to contemporary accounts. Daring young ladies would hike their skirts to wade in the surf, and they might all go bowling in the recreation building seen in the background of this photograph. The ferry *Ukiah* would be loaded to the gunwales with holiday seekers. (LMS Archives.)

El Campo was not the only picnic resort on the Tiburon Peninsula. In the early 1890s, these holiday seekers visited Lyford's Cove for a day's outing. All were properly attired for an elegant lunch at the beach. (LMS Archives.)

The Lyford Cove picnic grounds were acquired by the Keil family as a private estate in the 1890s. Several generations of Keils, including Russell and Bernidet Keil, have made it their home and preserved it from development. Now known as Keil Cove, it was the setting for the movie *Petulia* in 1967. (Keil family.)

Another popular picnicking spot is Ayala Cove on Angel Island. Through the 1960s and 1970s, the town of Tiburon held an annual outing called Ayala Day, commemorating the early explorer. Seven former mayors celebrating Ayala Day on Angel Island gathered for this photograph. Pictured here, from left to right, are Al Aramburu, Hal Edelstein, Larry Smith, Joan Bergsund, Branwell Fanning, George Ellman (who created Ayala Day), and Phil Bass. Ayala Day often featured a softball game between Tiburon and Belvedere.

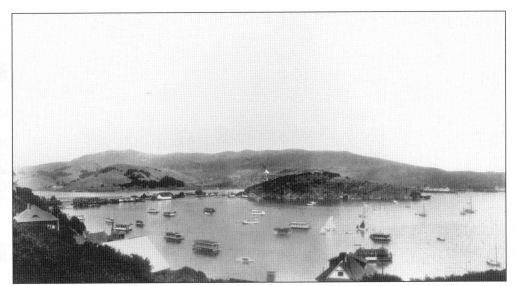

Belvedere Island was developed as a weekend getaway for wealthy San Franciscans. Not all built homes; some lived on houseboats, mostly moored in Belvedere Cove. Locally they were known as "arks" and had to be moved to the lagoon for protection in the wintertime. (LMS Archives.)

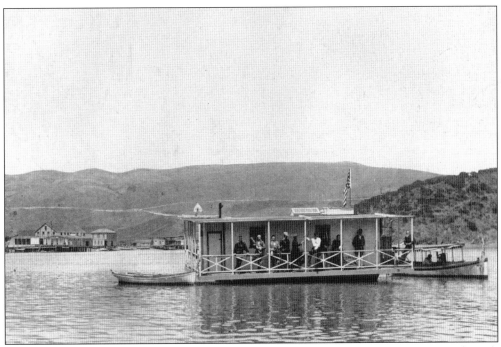

Many arks were of unique design and were built as much for partying as for living. Festivals, such as "A Night in Venice," were annual affairs, with the arks and many island homes festooned with Japanese lanterns and parades of decorated rowboats visiting between the arks. Sitting alone on the hill is the St. Hilary Mission Church. (LMS Archives.)

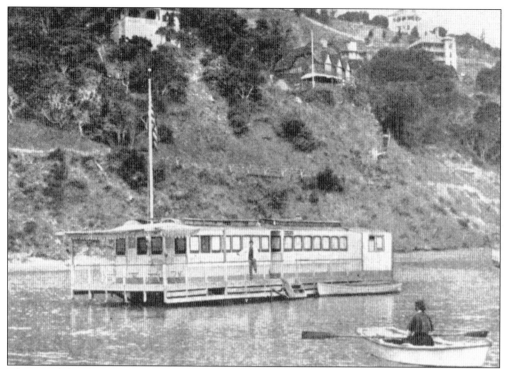

This creative ark was constructed of four retired San Francisco horse-drawn streetcars. It was quite spacious for an ark and had a very elaborate interior. The local weekly newspaper is called *The ARK*. (LMS Archives.)

In the 1950s, peninsula residents created the Southern Marin Recreation Center, or Rec Center. It was open to any resident of southern Marin. The entrance fee was $50, and monthly dues for a family were $10. A clubhouse, four tennis courts, and a swimming pool were constructed. As it grew to 10 tennis courts, two pools, a workout building, and a children's play yard, the name changed to the Tiburon Peninsula Club (TPC), a private club open to anyone living on the Tiburon Peninsula.

Members of the TPC, who called themselves the Pelican Players, put on an annual musical featuring local talent. The musicals are often takeoffs of other well-known productions. For instance, one year the production was called *West Shore Story*. In the story, a boy from the Tiburon Peninsula Club falls in love with a girl from the Belvedere Tennis Club, and the families will not condone such a match.

Recreation really hit a high point when the NWP Railroad ended service in 1967 and pulled up their tracks on a two-and-a-half mile strip of land bordering the Richardson Bay Sanctuary. Bicycle paths were not common around the bay then, and in spite of claims that "nobody would ever use it," the Tiburon Town Council immediately started legal action to acquire the right-of-way for a bicycle path.

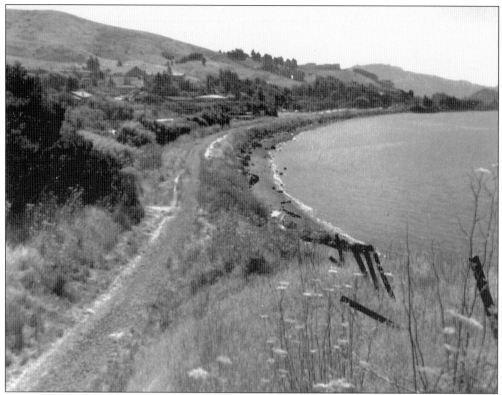

The right-of-way, perfectly level and pounded flat by 80 years of railroad use, made a marvelous bicycle path. There were still some people riding horses in the 1960s, so a bridle path was added. A few years later, the horses disappeared just about the time jogging became popular, and the bridle path became a jogging path.

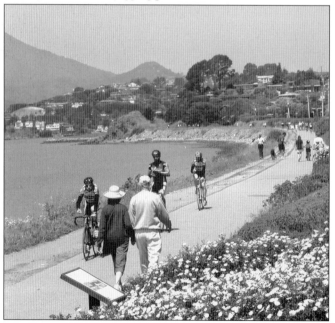

Starting at the Audubon Center, the multiuse path connects Blackie's Pasture, McKegney Green, South of the Knoll Park, the Richardson Bay Wildlife Sanctuary, Tom Price Park in Belvedere, downtown Tiburon, Ferry Plaza, Shoreline Park, and the Elephant Rock Fishing Pier— almost five miles of unbroken points of interest.On any sunny day, but especially on weekends, hundreds of people use the path. Dog walkers, baby-carriage pushers, bird watchers, bicyclists—young and old—can be seen enjoying some time by the bay.

Baseball is still a popular sport on the Tiburon Peninsula, for the little league diamonds at the Strawberry Recreation Center are busy all year. In the past, the diamonds down by the railroad yards produced athletes like Sam Chapman, an All-American in five sports at UC Berkeley, and who starred with the Philadelphia Athletics from the 1930s to the 1950s, with time out to fly for the navy in World War II.

The state and county planned to build a freeway in the bay and had filled in many acres of wetlands when the people put a stop to the idea. Tiburon acquired the right-of-way, which also paralleled the railroad tracks, and turned it into the soccer fields at McKegney Green, the South of the Knoll Park for small children, and added land to Blackie's Pasture.

Belvedere acquired the section of the highway right-of-way that was in Belvedere and created Tom Price Park, which included public tennis courts. Former Mayor Price never missed an opportunity to play tennis. Tiburon built an equal number of public courts at Del Mar School. There is a joint recreation district, and residents of both towns have equal access to all the facilities.

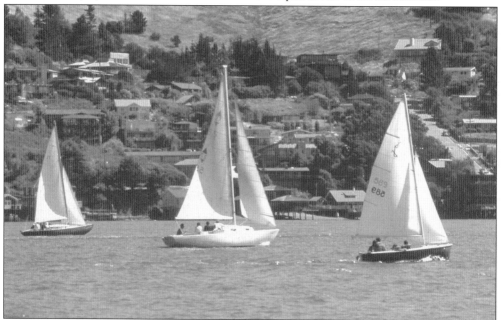

With bay frontage on three sides of the Tiburon Peninsula, sailing and yachting became the prevailing water sport. Three private yacht clubs and hundreds of waterfront homes with private docks provided the facilities.

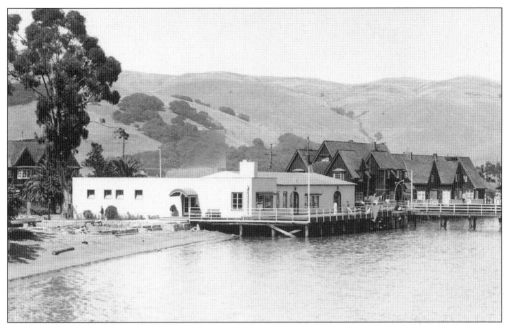

In 1934, the San Francisco Yacht Club finally found a permanent home after years of drifting in other harbors on the bay. The demise of the Hotel Belvedere gave them the opportunity to build this clubhouse on Belvedere Cove, where it stands today. (LMS Archives.)

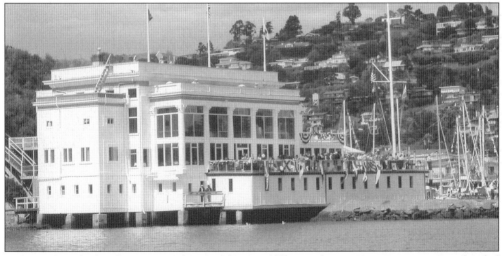

Eighteen hundred eighty-six was the year that small boat sailors on San Francisco Bay decided to start their own yacht club, with regattas for amateur yachtsmen instead of the prevailing big boats sailed by professionals. They called it Corinthian after the ancient amateur athletes. Their first yacht club burned down, and on July 4, 1912, the present white clubhouse, which continues to dominate the Tiburon waterfront, was opened. It was built in a little over one year and cost $25,000.

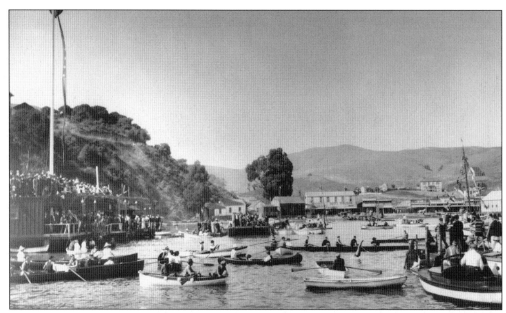

A huge crowd of boaters turned out for the opening of the new Corinthian Yacht Club. It was three stories high, had a wood-paneled ballroom, and a ladies room on the top floor (now the upstairs bar). The original charter stated that "no liquor, cigars or refreshments shall ever be sold on the premises." That rule did not last long. (LMS Archives.)

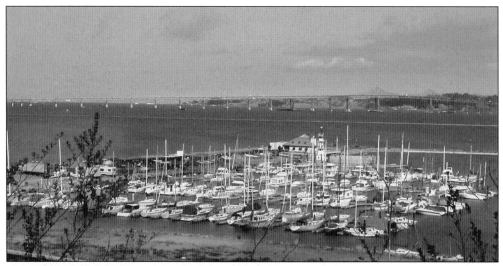

The Tiburon Yacht Club was established at the Paradise Cay development on Paradise Drive. Most of the homes in the development have private docks, and the yacht club serves as a social center as well as a harbor for non-residents to keep their boats.

Many homes on the Strawberry Peninsula have their own docks on Richardson Bay.

The Blessing of the Fleet is an annual event on Opening Day in Tiburon. Priests, rabbis, and ministers take turns offering blessings to hundreds of pleasure craft, which line up and pass by. Capt. Elmer Towle and Charles White of the Corinthian Yacht Club were the organizers of the event for many years. Pastor George Johnson of St. Hilary's Church in Tiburon participated in the blessing. All three are deceased, but the tradition continues.

When there was still a navy presence in San Francisco Bay, the U.S. Navy always provided a ship, anchored in Raccoon Strait, for the Blessing of the Fleet. Since the navy sailed away, the Coast Guard has provided the ceremonial platform.

By 1948, there were 15 to 20 families living in Strawberry. They formed a property-owners association, and Sam Neider, the developer, let them use this old red barn for a clubhouse. In 1949, the board of supervisors approved the forming of the Strawberry Recreation District, which could raise taxes. The red barn was unsafe and was torn down. (Strawberry Recreation District.)

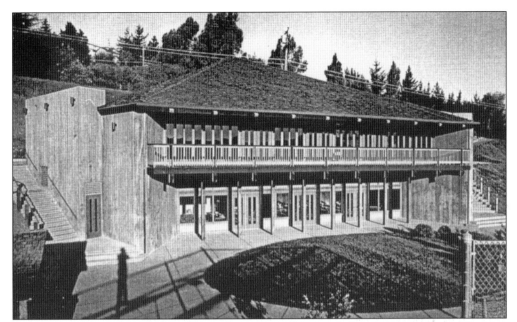

After the red barn was demolished, Strawberry was still in need of recreation facilities. Planning began in 1958, but it was not until 1970 that construction of this two-story community building got underway. Within its 9,700 square feet are a three-fourth-size basketball court, a kitchen, a stage, and meeting rooms for community activities. Tennis courts were added later, and the playing fields are used by soccer teams and the Tiburon Peninsula Little Leagues. (Strawberry Recreation District.)

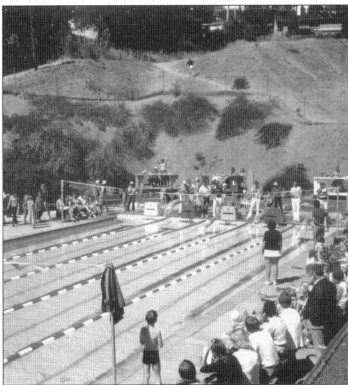

The Strawberry Recreation Center added this swimming pool in 1963. (Strawberry Recreation District.)

In January 1961, almost overnight, the Elephant Rock Fishing Pier appeared on the Tiburon waterfront. A young Tiburon lad by the name of Robert "Bunkie" Keener, who loved to fish, slipped off a railroad pier and drowned. The men in town did not wait for permits and other bureaucratic delays and simply gathered up the materials and built the pier for boys and girls under 16 to use.

Here is a good day's catch at the Elephant Rock Fishing Pier by a lucky fisherman. When the pier was rebuilt in 1999, it was improved to allow access for disabled persons, and the age restriction was eliminated.

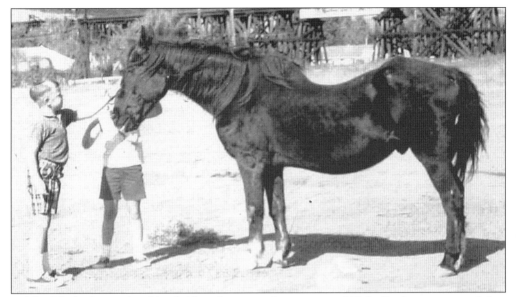

In life, "Blackie" was adored by children. Living to the great age of 40, his back was so swayed that his belly almost touched the ground, but to the kids he was still "Black Beauty." In his last years, he stood in a pasture at Trestle Glen almost immobile. When he died in 1966, he was buried in the pasture, which is still called Blackie's Pasture.

Blackie's death made the front pages of Bay Area newspapers and the cover of horse magazines across the country (why he was so famous is still not known). In any case, donations for a memorial came in. After a substantial contribution from the estate of Gordon Strawbridge, the first mayor, a life-size bronze statue of Blackie now stands in Blackie's Pasture, immobile as Blackie, to the delight of children too young to have fed sugar cubes and carrots to the original.

The Tiburon Peninsula Foundation took the lead in creating Blackie's Brigade to raise funds for the statue. Here longtime foundation president and former mayor Larry Smith looks over another of their projects—a series of weatherproof historic markers that line the waterfront trail. (Diane Smith.)

The little ones haven't been neglected either. A day's outing with dad at the Romberg Tiburon Environmental Center, playing with squishy things in tanks, is just right for these young biologists.

Seven

CHURCHES AND SCHOOLS

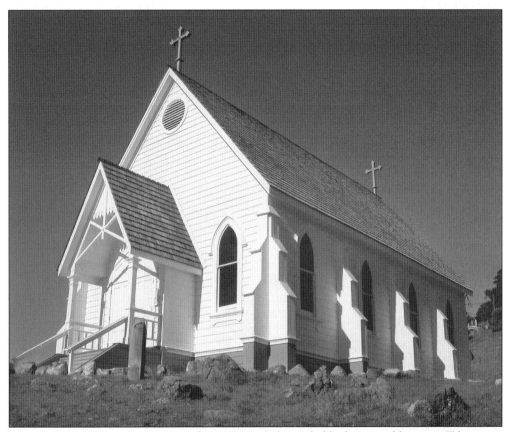

Beginning in 1888, a visiting priest from San Rafael traveled by horse and buggy to Tiburon to say Mass every other Sunday. This mission church had been constructed on a prominent hillside site donated by Dr. Benjamin Lyford and his wife, Hilarita Reed Lyford. Her mother was Hilaria Sanchez Reed. Not surprisingly, the mission was named after an early saint, Hilary, Bishop of Poitiers, France, who died in 368 and was the family patron saint.

The stark simplicity of the restored interior of old St. Hilary's is the perfect setting for a wedding. Many other local celebrations and meetings take place in the number-one historical setting on the peninsula. A profusion of wild flowers, some found nowhere else, surround the old mission.

In 1954, a new St. Hilary's was completed and the old mission church was de-sanctified and the last Mass offered. In 1959, the Archdiocese offered to sell it for $10,000. The Belvedere Tiburon Landmarks Society was formed to acquire and preserve the historic church; the Dakin family of Tiburon donated the entire amount. (The Dakins and six members of their family were killed in a plane crash in 1966.) Dakin Lane leads to the old mission today.

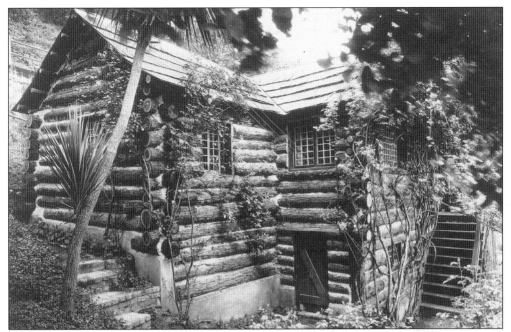

This log cabin, built around 1892 in Belvedere, rolled down the hill in a jumble of logs during the El Niño storm of 1982. For 45 years, starting in 1907, it had served as the church for the Christian Science Society of Belvedere. (LMS Archives.)

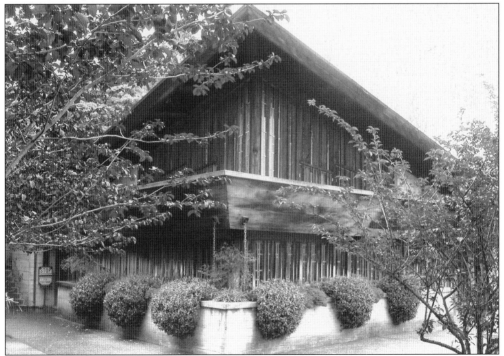

Architect Charles Warren Callister won awards for the best contemporary ecclesiastical design in the country for this 1952 replacement for the log cabin. The First Church of Christ, Scientist, Belvedere, intentionally relates to the prow of a sailing ship.

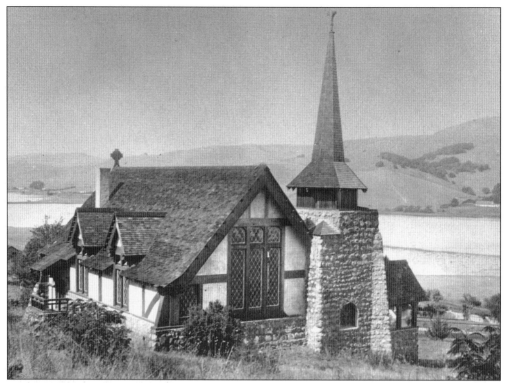

Built in 1896, the peninsula's first Presbyterian church, designed by Albert Farr in English half-timber style, stood at the corner of Bayview and Laurel Avenues in Belvedere. In 1928, it was leased to St. Stephen's Episcopal Mission.

The original Presbyterian church in Belvedere was sold to the city in 1949, moved down the hill, and became city hall. It has been expanded several times but kept the English half-timbered look of the original design. The Belvedere School was built on the former church site. When it closed, the main building was converted to condominiums.

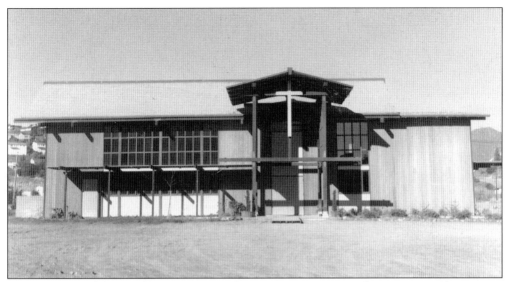

It was not until 1957 that Presbyterians on the peninsula found a new home—a rented room over an ice-cream parlor. That only lasted until 1960, when the Westminster Presbyterian Church opened on Tiburon Boulevard in this modern building. A 3,600-square-foot sanctuary was added in 1991. One of the stained-glass windows from the original church in Belvedere was returned in 1979 by the Landmarks Society.

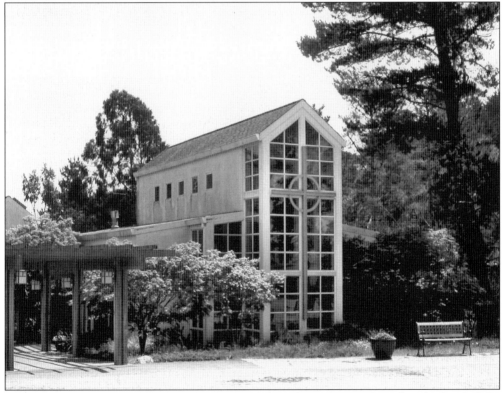

The newest addition to the theological world on the Tiburon Peninsula is the Shepherd of the Hills Lutheran Church on Shepherd Way near Trestle Glen.

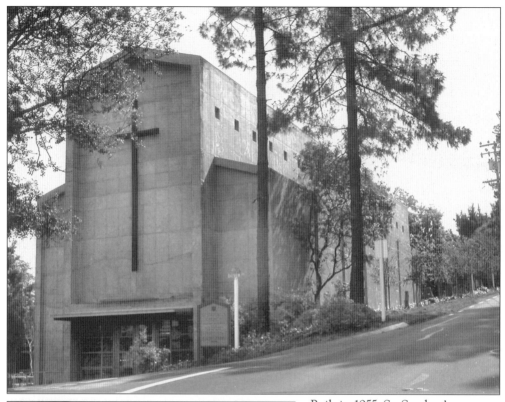

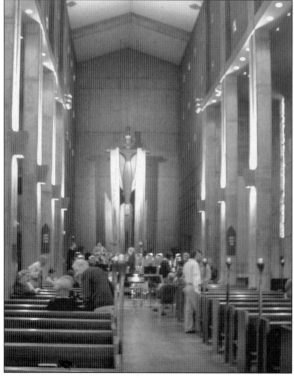

Built in 1955, St. Stephen's Episcopal Church in Belvedere is like a miniature Gothic cathedral in its use of space. The site, part of the original Belvedere Golf Club, was sold to the parish by the Land Company before they subdivided the course.

Once inside St. Stephen's Church, it is easy to stop thinking about the dimensions of the building and project the image of a great European cathedral in one's mind. The acoustics are outstanding, and many music programs are held here.

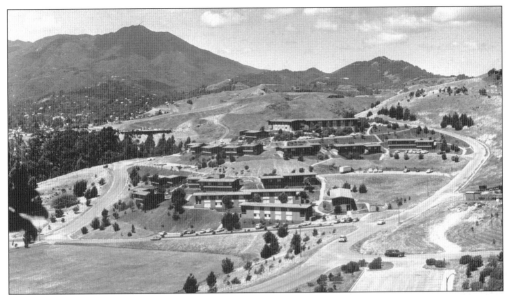

In 1952, the Golden Gate Baptist Seminary, then in Berkeley, desired a new campus. Stated in a directive from the church while looking for the new center, "But where is there 100 acres of land in a good neighborhood, close to transportation, access to main highways, and not too distant from suitable housing and possible secular employment for students? A place of prominence on a rising hill, the surrounding homes of the highest type, and the community shall desire such an institution." A site on Strawberry Point, which had been in the finals for the headquarters of the United Nations but had missed the cut, was available.

Pres. Harold Graves and trustee E. H. Westmoreland set a time capsule. The new Strawberry Point campus of the Golden Gate Baptist Seminary officially opened on July 1, 1959. It consisted of three housing villages, men's and women's dormitories, a cafeteria and student center, a classroom building, and administrative offices. This is the only institution of higher learning on the Tiburon Peninsula.

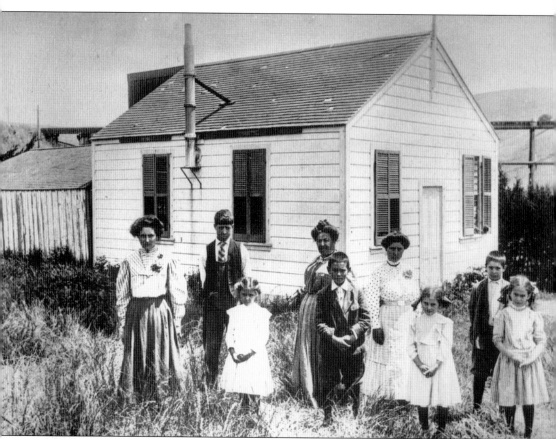

The first Reed School was used from 1874 until 1921. It was located next to the long trestle in what is now Belveron Gardens West. It served the children of the dairy and railroad workers. Belvedere had its own school district, and the Strawberry schools were annexed to the Mill Valley district. (LMS Archives.)

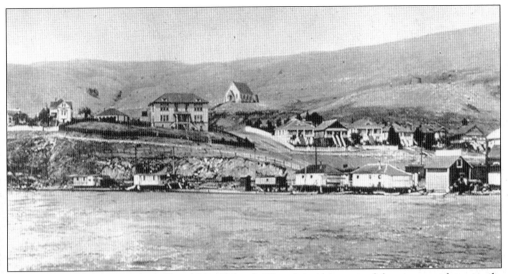

The center building atop the hill is old St. Hilary's Church in this turn-of-the-century photograph. The large building just below it is the second Tiburon school. In 1949, the Belvedere and Tiburon School Districts were combined into the Reed Union School District. In 1954, a new Reed School was completed on the site of the former Hilarita Dairy. (LMS Archives.)

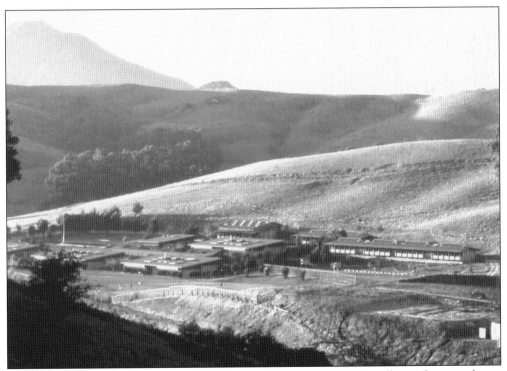

In 1960, Bel Aire School was completed to prepare for the expanding enrollment from new home construction. The school was built near the site of the original Reed Dairy. County policies would have permitted thousands of homes covering these hills, and the school board started to plan for the influx of students. Tiburon's incorporation changed the plan to more open space and fewer houses.

Generations of students in grades three through five have attended the Bel Aire School in this building. Most of the school has been demolished and is being replaced with an up-to-date facility.

The more recent Reed School was completed on the site of the Hilarita Dairy in 2005 as part of a complete rebuilding of the Reed District schools.

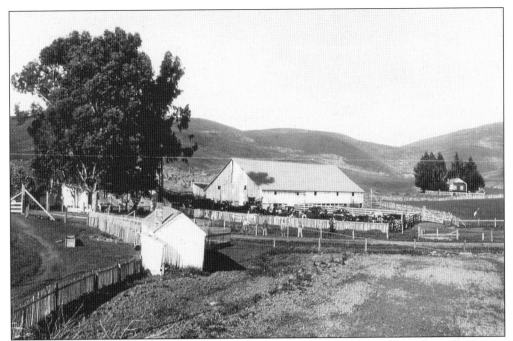

Del Mar School, on the site of the Little Reed Ranch Dairy, came in 1964, and the district established the configuration that is still used. Reed School educates children in kindergarten and grades one and two. Grades three, four, and five are at Bel Aire, and the sixth, seventh, and eighth grades are at Del Mar. The Tiburon School became Bradley House, a senior citizen residence, and the Belvedere School was sold for condominiums.

Del Mar School is scheduled to have a complete makeover in the next several years, including a new gymnasium and computer wiring. In 2005, wireless laptop computers were issued to all students at Del Mar for use in school and at home.

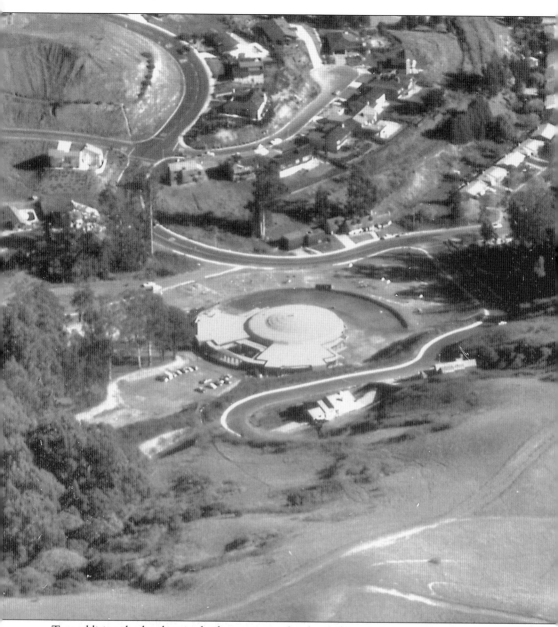

Two additional schools were built to prepare for the influx of students that never materialized. Granada Middle School was constructed for Corte Madera students who live in the Reed district. It was used for about 10 years and then it closed, but it was retained by the district as offices and for future use. Reedland Woods Middle School (with white dome) opened in 1970 and closed in 1976. The facility was sold to Congregation Kol Shofar and is the only temple on the peninsula.

Eight

ANGEL ISLAND

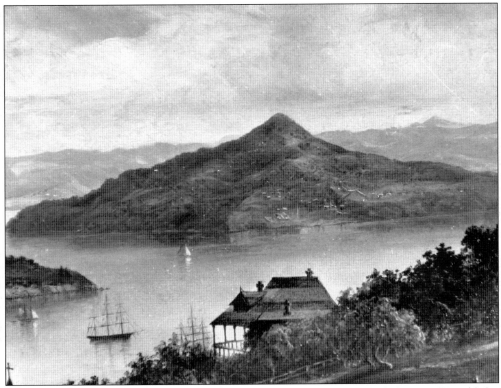

Named Isla de Neustra Senora de los Angeles by Lieutenant Ayala and Isla de la Santa Maria de los Angeles by Father Vincente (the chaplain on the *San Carlos*), the largest island in San Francisco Bay has been called Angel Island since the arrival of the Americanos. Incorporated as part of the Town of Tiburon in 1964, the island has served as a cattle ranch, part of the coastal defense system, an immigration station, a hospital for military personnel and immigrants, a prisoner of war camp, a Nike missile base, and since 1962, a state park. This drawing shows the island before the top was removed for a radar station. It has recently been restored. (All photographs in this chapter are from the Angel Island Association.)

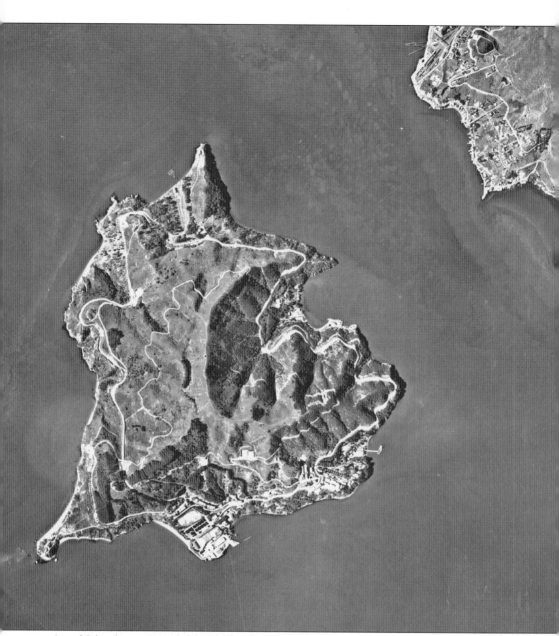

Angel Island was part of the Tiburon Peninsula 10,000 years ago. A period of global warming thawed the glaciers covering North America; the oceans rose, and a mile-wide gap separated Angel Island from the mainland. Fourteen acres of the 740-acre island are in the city of San Francisco, and the rest is in the Town of Tiburon. From 1839 until 1860, the island was owned by a Mexican rancher, Don Antonio Maria Osio. It became property of the U.S. government in a ruling by the Supreme Court.

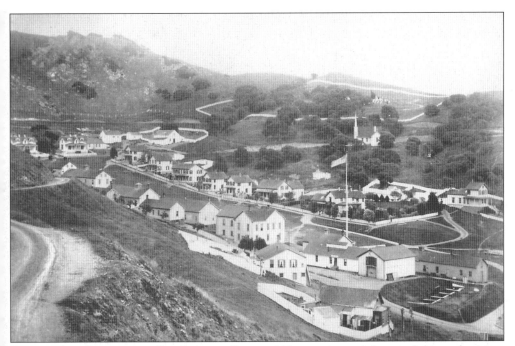

Any invading fleet entering San Francisco Bay would have as its goal the naval shipyard at Mare Island or the armory at Benicia, and they would have to turn north and pass close by Angel Island, or so the Civil War military planners in Washington believed. In 1863, defense works were constructed consisting of several gun batteries, and Camp Reynolds was established to house the soldiers manning these batteries. It is undergoing restoration by the Angel Island Association.

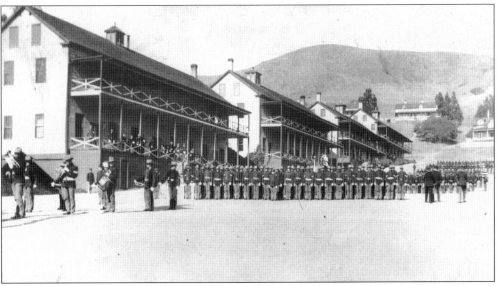

Two additional bases were built on the island and, in 1900, all three combined as Fort McDowell, with Camp Reynolds becoming West Garrison. The parade ground at Camp Reynolds had officer housing smartly lined up on one side and barracks on the other side, where these troopers are ready for morning drill. Military hospitals were built surrounding what became known as Hospital Cove.

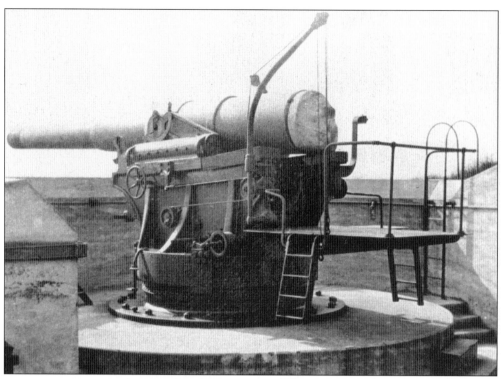

There were very few guns actually installed on Angel Island as the possibility of invasion diminished. Fort McDowell became the headquarters for the 12th Infantry, as well as the 9th. From the 1860s to the 1880s, both units were off fighting the "Indian Wars" throughout the western states.

The army band was popular on the island for dances and concerts. Before the days of radio communications and loud speakers, army musicians played a dual role as part of the communication system, calling the men to formation, meals, etc.

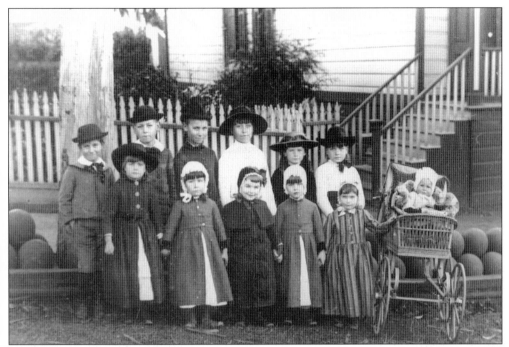

With thousands of officers and men on the island, there were a number of families as well. Schools were set up for the children who were properly dressed for the occasion. Note the size of the cannonballs stacked on each side of the children in this photograph.

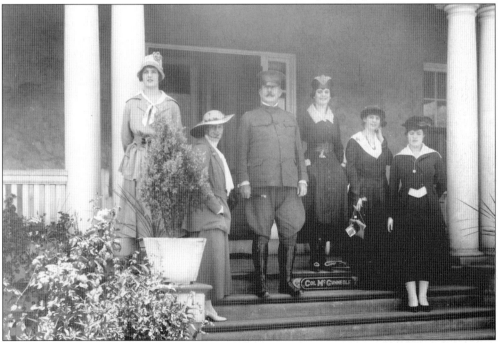

An officer and several ladies pose on the steps of a home assigned to a Colonel McGunnegle. Between wars, Angel Island was considered choice duty. The weather was favorable, San Francisco was close by, and officers and senior enlisted men could have their families with them.

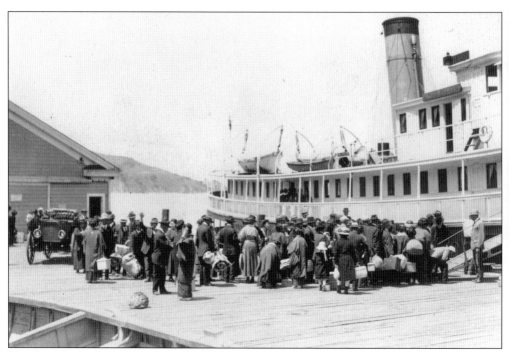

The fear that a disease, such as smallpox, could be introduced into San Francisco by a ship coming from Asia required that the Immigration Service screen all passengers. After 1891, all passengers and luggage were off-loaded and transferred to Angel Island. Immigrants were checked for disease, while luggage and cargo were fumigated by steam from the retired warship *Omaha*, anchored at Angel Island.

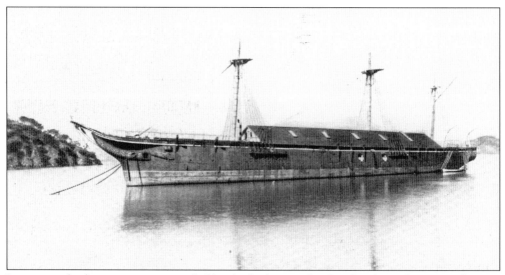

Live steam for fumigation was provided by the boilers on the *Omaha*. A combination of steam, formaldehyde, and ammonia was used as a disinfectant in 40-foot-long, 7-foot-wide steel tubes at the quarantine station. Passengers had to stay in the barracks until the entire ship had been cleared, which could take a month or more.

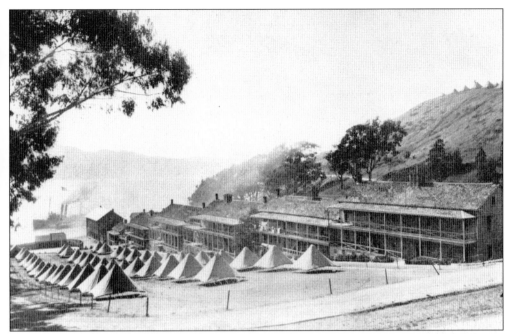

Camp Reynolds was overflowing at the time the United States entered World War I. Extra tents were added on the parade grounds. The main embarkation ports were on the East Coast, but Fort McDowell was the training ground for thousands of troops.

DISINFECTED

...............189 ,

AT THE

NATIONAL QUARANTINE STATION,

ANGEL ISLAND, CAL.

In accordance with the regulations of the Treasury Department.

U. S. Marine-Hospital Service,

Surgeon U. S. M. H. S.

(OVER)

Passengers and luggage were "tagged" with this emblem, issued by the surgeon from the U.S. Marine Hospital Service at the National Quarantine Station on Angel Island. (Ken Harrison provided this tag.)

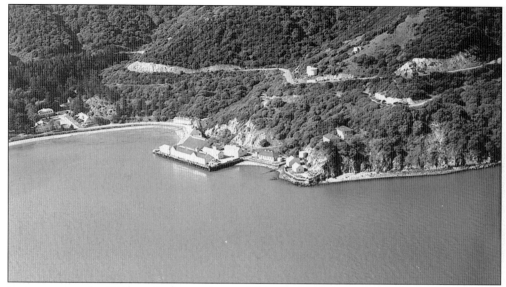

In response to the Chinese Exclusion Act in 1882, the Immigration Service built a station on a remote cove on the north side of Angel Island. An Asian immigrant could still come to the United States, but it was a complex process and could take many months, possibly even years. Families were separated while paperwork was being studied. Immigrants carved elaborate poems in the wooden walls of the dormitories where they were held.

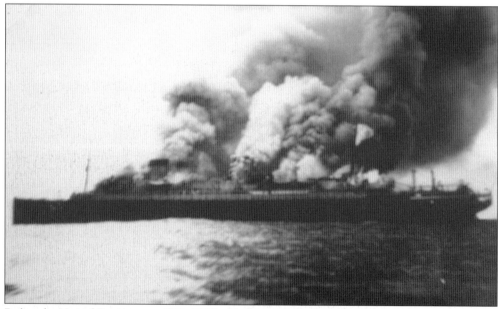

Before the United States entered World War II, the *Columbus*, a German luxury liner, was scuttled off the East Coast to avoid capture by the British. Seven hundred civilian crewmen were rescued and brought ashore in New York. Because there was no way home via the Atlantic, they were brought to Angel Island, where they remained for more than a year. They were later transferred to camps in New Mexico and were sent home after the war.

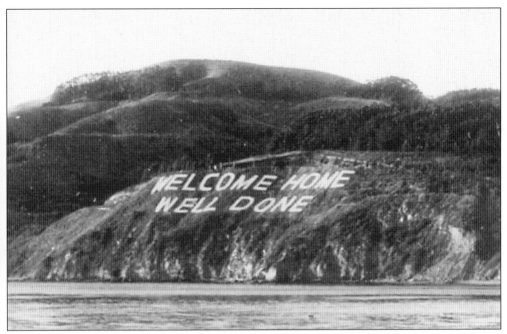

Around 300,000 men were sent to the Pacific theater out of Angel Island during World War II. Those who made it back were greeted by this sign. A POW camp had been setup for German prisoners during the war. Some Japanese and a few Italians were also there but not many.

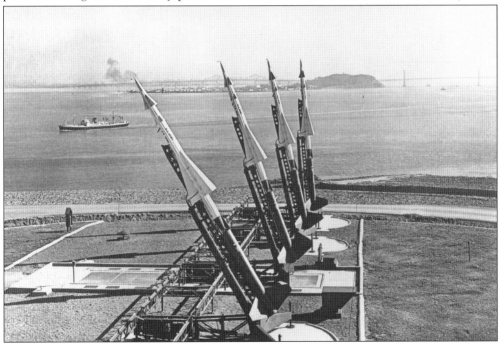

The last military service of Angel Island was during the cold war. In 1952, the top of the island was sliced off for a radar station that controlled missile launching pads. The Nike air-defense system was part of a plan to shoot down Soviet bombers before they reached U.S. shores. Intercontinental ballistic missiles made the system obsolete, and it was removed in 1962.

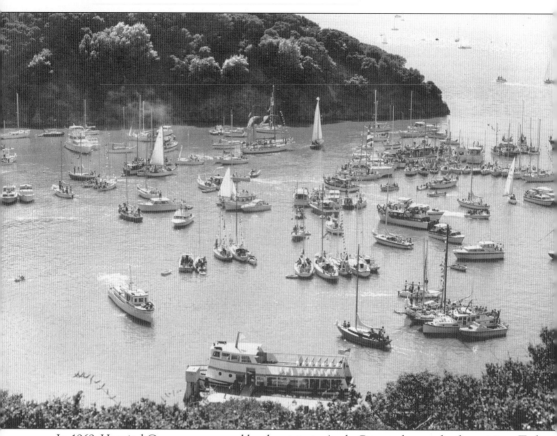

In 1969, Hospital Cove was renamed by the state to Ayala Cove to honor the first visitor. Today there is ferry service from Tiburon and other cities on the bay bringing thousands of visitors to the island. Private yachts fill the cove on weekends, making this one of the most popular parks in the California park system.